LEGENDARY LOCALS

OF

COVENTRY

RHODE ISLAND

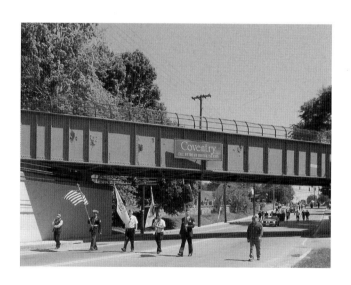

Map of Coventry
This map of Coventry was drawn in honor of the bicentennial celebration of the United States and highlights points of historical interest. A few of the images on this map are featured in this book. (Courtesy of Western Rhode Island Civic Historical Society.)

Page 1: Coventry Pride Sign
This sign is one of two that adorn an old train bridge that is now part of the Coventry Greenway, a bike path and walking trail that connects Coventry to other towns in Rhode Island. This sign represents the spirit of the residents of Coventry. (Author's collection.)

LEGENDARY LOCALS
—— OF ——

COVENTRY
RHODE ISLAND

ANDREW D. BOISVERT

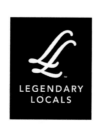

LEGENDARY
LOCALS

Copyright © 2013 by Andrew D. Boisvert
ISBN 978-1-4671-0104-2

Legendary Locals is an imprint of Arcadia Publishing
Charleston, South Carolina

Printed in the United States of America

Library of Congress Control Number: 2013937725

For all general information, please contact Arcadia Publishing:
Telephone 843-853-2070
Fax 843-853-0044
E-mail sales@arcadiapublishing.com
For customer service and orders:
Toll-Free 1-888-313-2665

Visit us on the Internet at www.arcadiapublishing.com

Dedication
This book is dedicated to the residents who have allowed me to write their stories and the stories of their ancestors; may your tales inspire future generations.

On the Front Cover: Clockwise from top left:
Alphee Bleir, Showboat owner (courtesy of Pawtucket Valley Preservation and Historical Society; see page 18); Diane Simmons, youth-services librarian (author's collection; see page 103); William Marcotte, dry-cleaner (author's collection; see page 48); Gail Tatangelo, community gardener (courtesy of Robert Robillard; see page 75); Searles Capwell, mill owner and politician (courtesy of Coventry Historical Society; see page 40); Joseph and James Maguire, lace-and-warping mill operators (author's collection; see page 46); Deana Borges, All Booked Up (author's collection; see page 24); William C. Rathbun, Civil War soldier (courtesy of Rachel Pierce; see page 29); Peter Stetson, Coventry High School science teacher (author's collection; see page 94).

On the Back Cover: From left to right:
Stamatis Karapatakis, Gelina's Ice Cream proprietor (author's collection; see page 24), Lauren Costa, *Coventry Patch* editor (author's collection; see page 109).

CONTENTS

Acknowledgments 6

Introduction 7

CHAPTER ONE Native American Folklore 9

CHAPTER TWO Founding Families 13

CHAPTER THREE Let Me Entertain You 17

CHAPTER FOUR Bravery on the Battlefield 27

CHAPTER FIVE Lumber, Lace, Stores, and More 39

CHAPTER SIX Community Contributors 67

CHAPTER SEVEN Authors and Educators 91

CHAPTER EIGHT News of the Day 105

CHAPTER NINE Boston Post Cane Recipients and Honorees 111

CHAPTER TEN Faith of the Immigrants 119

Index 127

ACKNOWLEDGMENTS

The following people deserve special note for opening doors and making the introductions to the many individuals who provided me with the stories and the pictures that have made this book possible: Norma Smith, Rachael Pierce, Thomas Pierce, Erma Pierce, Brenda Jacobs, Lauren Costa, Raymond Wolf, Richard Siembab, and Lois Sorenson. The organizations that allowed me access to their amazing collections were the Western Civic Rhode Island Historical Society, the Coventry Historical Society, and the Pawtuxet Valley Preservation and Historical Society.

I would also like to thank the following people for taking the time to sit down and tell me their stories and memories: Gail Holland, Gail Tantentaglo, Robert N. Robillard, William F. Marcotte, Guy Lefebvre, Everett "Junior" Hudson Jr., Fr. Paul R. Grennon, Donald Card, Donna Cole, the Hawkins family, Rosemarie and Bruce Guertin, the Skaling family, Diane Simmons, Gail Slezak, Joel Johnson, Patrick Malone, Chief Bryan J. Volpe, Joseph and James Maguire, Robert Maguire, Philip and Coreen St. Jean, Linnea Feraro, Freda Fisher, Robert and Tillie Phillips, Dave Jervis, Tom Jervis, Bob Amaral, Jeffery Hakanson, Louis and Nico Zarakostas, Deana Borges, Cheryl Ring, Jessilyn Ring, Kelly Bryant, Stamatis Karapatakis, Charlie Patel, George Proffitt, Ray Gandy, Fred Curtis, Christopher Moore, Sandy Farnum, Charles Vacca, Linda Crotta Brennan, Peter Stetson, Nichole Hitchner, Robert Grandchamp, Mary Colvin Thompson, and Richard Seelenbrandt.

Special thanks go to my parents, Paul and Sandra Boisvert, who have acted as a sounding board, research team, and overall support staff during the writing of this book.

Unless otherwise noted, all images appear courtesy of the author. Some images noted in this volume appear courtesy of Pawtuxet Valley Preservation and Historical Society (PVPHS), Coventry Historical Society (CHS), and the Western Rhode Island Civic Historical Society (WRICHS).

CONTENTS

Acknowledgments 6

Introduction 7

CHAPTER ONE Native American Folklore 9

CHAPTER TWO Founding Families 13

CHAPTER THREE Let Me Entertain You 17

CHAPTER FOUR Bravery on the Battlefield 27

CHAPTER FIVE Lumber, Lace, Stores, and More 39

CHAPTER SIX Community Contributors 67

CHAPTER SEVEN Authors and Educators 91

CHAPTER EIGHT News of the Day 105

CHAPTER NINE Boston Post Cane Recipients and Honorees 111

CHAPTER TEN Faith of the Immigrants 119

Index 127

ACKNOWLEDGMENTS

The following people deserve special note for opening doors and making the introductions to the many individuals who provided me with the stories and the pictures that have made this book possible: Norma Smith, Rachael Pierce, Thomas Pierce, Erma Pierce, Brenda Jacobs, Lauren Costa, Raymond Wolf, Richard Siembab, and Lois Sorenson. The organizations that allowed me access to their amazing collections were the Western Civic Rhode Island Historical Society, the Coventry Historical Society, and the Pawtuxet Valley Preservation and Historical Society.

I would also like to thank the following people for taking the time to sit down and tell me their stories and memories: Gail Holland, Gail Tantentaglo, Robert N. Robillard, William F. Marcotte, Guy Lefebvre, Everett "Junior" Hudson Jr., Fr. Paul R. Grennon, Donald Card, Donna Cole, the Hawkins family, Rosemarie and Bruce Guertin, the Skaling family, Diane Simmons, Gail Slezak, Joel Johnson, Patrick Malone, Chief Bryan J. Volpe, Joseph and James Maguire, Robert Maguire, Philip and Coreen St. Jean, Linnea Feraro, Freda Fisher, Robert and Tillie Phillips, Dave Jervis, Tom Jervis, Bob Amaral, Jeffery Hakanson, Louis and Nico Zarakostas, Deana Borges, Cheryl Ring, Jessilyn Ring, Kelly Bryant, Stamatis Karapatakis, Charlie Patel, George Proffitt, Ray Gandy, Fred Curtis, Christopher Moore, Sandy Farnum, Charles Vacca, Linda Crotta Brennan, Peter Stetson, Nichole Hitchner, Robert Grandchamp, Mary Colvin Thompson, and Richard Seelenbrandt.

Special thanks go to my parents, Paul and Sandra Boisvert, who have acted as a sounding board, research team, and overall support staff during the writing of this book.

Unless otherwise noted, all images appear courtesy of the author. Some images noted in this volume appear courtesy of Pawtuxet Valley Preservation and Historical Society (PVPHS), Coventry Historical Society (CHS), and the Western Rhode Island Civic Historical Society (WRICHS).

INTRODUCTION

In 1642, the Shawomet tribe sold the area between the salt water and the Connecticut border, which would become known as the Shawomet Purchase, to Samuel Gorton and his 11 associates for 144 fathoms of wampumpeag. Samuel Gorton and his associates began settling the portion of the Shawomet Purchase now known as Apponaug and its surrounding area, now known as Warwick, because of its proximity to water and because the Indians had already cleared it, making it an ideal site for settlement. In 1644, Samuel Gorton sailed for England to defend the colony. While in England, he received help in acquiring a proper deed from Robert Rich, Earl of Warwick, and that is when they changed the name from Shawomet to Warwick.

In 1675, there was a Native American uprising in New England led by Metacomet, also known as King Philip, to drive the English people off the land. Originally, the war consisted of just Wamponoag Indians, but eventually the Narragansett Indians got involved, and together they burned settlements, including Warwick. Finally, King Philip was killed by the English settlers, and the war ended in 1676. Samuel Gorton, surviving associates, and the next generation of descendants began rebuilding Apponaug and its surrounding area.

Sometime between 1677 and 1682, the town council of Warwick gave land in what is known today as the Washington/Anthony area of Coventry to John Warner, Henry Wood, John Smith, and John Greene for the construction of a sawmill. In 1682, Henry Wood sold his portion of the sawmill to John Greene and Richard Carder. Greene, Smith, Carder, and Warner ran the sawmill from 1687 until 1691, when Warner sold his share to Mark Roberts, and Roberts sold his share to Nathanael Cahoon, who ended up selling his share to Samuel Bennett. Bennett later sold his share to Francis Brayton.

In the 1690s, settlers finally began building homes in this area. The early settlers voted to divide the land into farms and marshlands. The first survey of the area was taken in 1692, and beginning in 1701, the town was divided into four tracts of land over the course of the next 34 years. In 1739, the colony line was resurveyed and more land was added, which was divided into 14 lots.

By the 1730s, the population of this area had doubled. Many families had already been living here for a while and were tired of having to travel to the village of Apponaug, which was the municipal center of Warwick, to conduct their civic business. So in 1741, these citizens petitioned the Rhode Island General Assembly to form a new town. The petition passed, and the town of Coventry was formed, which became the 16th municipality in the state. The name of the town comes from Coventry, England, which had been home to some the founders of Coventry, Rhode Island.

Before 1750, all of the towns located in what is now Kent County were part of Providence County. In the 1800s, local industrialists began cotton and woolen mills along the rivers, and the villages were named for these industrialists or for geographical landmarks. The coming of the railroad helped to unite the villages and move goods between them. With the coming of more jobs came immigration, which changed the ethnic makeup of Coventry but not the sense of community spirit. The late 19th century and the early 20th century saw little change to the life in Coventry, and farms and mills coexisted.

In 1941, in honor of the 200th anniversary of the founding, a town seal was created by Howard M. Chapin. The seal is based on the coat of arms given to the town of Coventry, England, in 1345 by King Henry III. After World War II and during the baby boom, Coventry experienced some growing pains, and the need for new housing developments and schools became very apparent. Farmland was no longer used for farming but became available for these developments and schools. Another aspect of the growing pains was the need for a permanent police force not based on political appointment, so in 1948 the town voted to establish one.

In the 1950s, Coventry became home to many lace mills that provided lace to the garment district of New York and employed many local residents. During the 1960s, the town council established guidelines for redevelopment and began zoning certain areas for residential use and others for commercial. The town expanded again in the 1970s with the arrival of strip malls, new roads, and a new high school to again meet the growing demand of its residents. At the end of the 20th century, a new industrial park was constructed, bringing in new residents and new homes, but the fact remains that many residents of Coventry today still identify with the village they live in.

Everyday life in Coventry is much the same as it was 25, 50, or in some cases, 100 years ago. There are still small family farms, mom-and-pop businesses, restaurants, and clubs that have been in business for a generation or two, and families still worshiping in the churches established by their ancestors. In this book, readers will learn about Samuel Gorton, a friend of the Native Americans who fought for religious freedom; George Potter, a Medal of Honor recipient for his service in the Civil War; Byron Read, who opened the town's first furniture emporium; Ray Gandy, who swam the English Channel; Linda Crotta Brennan, who has provided the children with many stories; Lauren Costa, who presents the news of the day; and Philip Johnson, who was a Boston Post Cane recipient. Joseph Maguire, who learned the lace trade as a young man, continues to operate a small shop producing lace the old-fashioned way. These and many others have interesting stories that tell of the hardships, friendships, heartaches, and memories that make up the people of Coventry.

CHAPTER ONE

Native American Folklore

For approximately 33 years, English settlers in the area that would become known as Coventry were interacting with Native American tribes. They were trading with them and learning the Native American customs and probably the folklore. As a result of being replaced by English customs, very little physical evidence remains today of a culture that had existed for a millennium, but what does remain are the legends. The legends that came from these interactions are loosely based in fact, and this chapter shows how the natives and early settlers used folklore to explain certain characteristics of the landscape. As the Native Americans did not put their legends down in written form, these retellings are reliant upon the written accounts of English settlers such as Samuel Gorton and Roger Williams.

It is written that Miantonomo, chief sachem of the Narragansetts, signed a land deed conveying the area known as Shawomet to Samuel Gorton and his associates. Black Rock and Carbuncle Pond in Coventry were included in this purchase; according to folklore, these spots were sacred to the Native Americans. The rock and the pond were part of the natural landscape and are still in existence today. The Native Americans had a different view of land usage and incorporated nature into all their beliefs. Rocks—like Black Rock in this chapter—and animals were known to be included in their mythology. Snakes rarely had any positive qualities and were often associated with violence and revenge in many Native American cultures. Carbuncle Pond and the legend of the snake included in this chapter might have come about as a way to stop the Indians or the settlers from drinking the water because it might not be safe, or it might have been to explain the color of the water. Some thought it might be that this was a sacred area, maybe a burial place, and the Indians were trying to protect it. However the legend developed, it was significant enough to have survived all these years.

Samuel Gorton

Samuel Gorton, who was born in England and had immigrated first to Massachusetts and then to Rhode Island, was the founder of the town of Warwick. As an early settler, he would have been given tracts of land, and some of this land was in the section that is now Coventry. Though Gorton never lived in the area that became Coventry, many of his descendants did. The Gorton family settled along Harkney Hill near the Maple Root Baptist Church where they worshipped. Many of Gorton's descendants became businessmen, soldiers, and sailors. (Courtesy of Gorton Junior High School.)

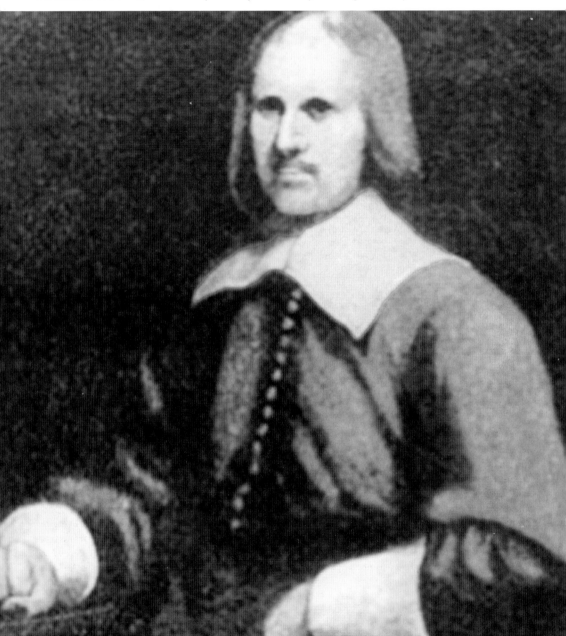

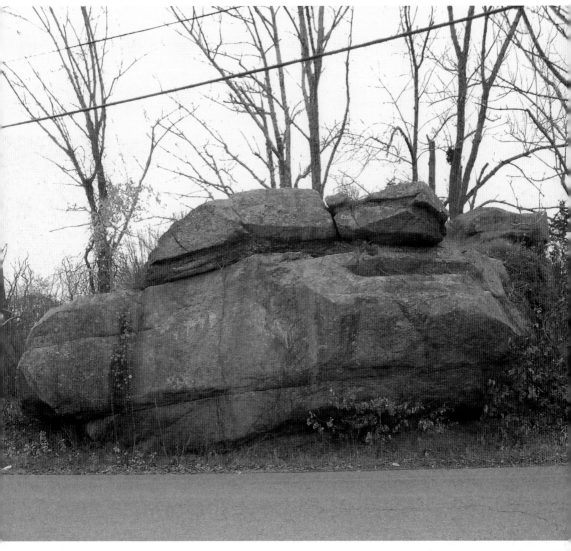

Black Rock

Long before the arrival of English settlers to Coventry, the area was home to the mighty Narragansetts and smaller tribes such as the Nipmuc, Scatacoke, Aqueednuck, Quidneck, Mishnick, and the Tipecanset. These tribes settled along the marshlands, rivers, and ponds and used their resources to hunt, fish, farm, and hold ceremonies. Through archeological excavation, it was determined that a Native American village once stood along the bank of the Pawtuxet River not far from Black Rock. According to legend, this large, dark piece of granite was the site of Native American marriage ceremonies. Besides being an important part of Native American culture, it has provided the name for this section of Coventry as well as the name for an elementary school and a pond. In a 1949 news article, the rock was referred to as a landmark, and though it was not an official designation, it has become a landmark used by the local people of Coventry.

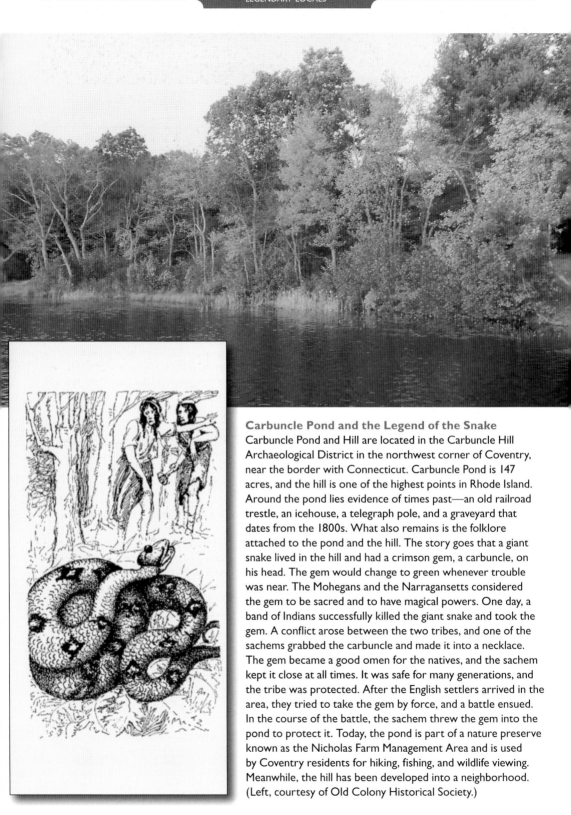

Carbuncle Pond and the Legend of the Snake
Carbuncle Pond and Hill are located in the Carbuncle Hill
Archaeological District in the northwest corner of Coventry,
near the border with Connecticut. Carbuncle Pond is 147
acres, and the hill is one of the highest points in Rhode Island.
Around the pond lies evidence of times past—an old railroad
trestle, an icehouse, a telegraph pole, and a graveyard that
dates from the 1800s. What also remains is the folklore
attached to the pond and the hill. The story goes that a giant
snake lived in the hill and had a crimson gem, a carbuncle, on
his head. The gem would change to green whenever trouble
was near. The Mohegans and the Narragansetts considered
the gem to be sacred and to have magical powers. One day, a
band of Indians successfully killed the giant snake and took the
gem. A conflict arose between the two tribes, and one of the
sachems grabbed the carbuncle and made it into a necklace.
The gem became a good omen for the natives, and the sachem
kept it close at all times. It was safe for many generations, and
the tribe was protected. After the English settlers arrived in the
area, they tried to take the gem by force, and a battle ensued.
In the course of the battle, the sachem threw the gem into the
pond to protect it. Today, the pond is part of a nature preserve
known as the Nicholas Farm Management Area and is used
by Coventry residents for hiking, fishing, and wildlife viewing.
Meanwhile, the hill has been developed into a neighborhood.
(Left, courtesy of Old Colony Historical Society.)

CHAPTER TWO

Founding Families

Permanent settlement in the region that is modern Coventry did not begin until the end of the Native American conflict known as King Philip's War. The land that had been purchased in 1642 by Gorton and his associates was now ready to be settled by the original purchasers or their descendants. In 1672, the proprietors of the area known as Warwick divided the area that would become Coventry into two large tracts of land. The line down the middle became known as the dividing line, or the seven and ten line. The land north of the dividing line was known as Seven Men's Farms, and the land south of the line was known as the "land above the great river."

When English settlers—such as Randal Holden Jr., John Carder, James Carder, Moses Lippitt, John Knowles, and John Wickes—first arrived here in the late 17th and early 18th centuries, Coventry was still wilderness. Families began clearing land and building homes along existing Indian paths or rivers. Two of the Indian paths would become known as the Great North Road and the Eight Rod Highway. Today the Great North Road is still in existence, but is paved and called Route 14 or Plainfield Pike. The Eight Rod Road today is a portion of Route 3 turning onto Harkney Hill Road and heading toward Voluntown, Connecticut. The farthest point west settlers went was in what is now Greene. They settled along the Moosup River on tracts of land called head lots.

Homes constructed during this time followed a traditional architectural style: one story with a central or end chimney made of fieldstone. The material for the homes came from the land being cleared. After the land had been cleared, the settlers turned to setting up water-powered grist- and sawmills and erecting their houses. Some families, such as the Braytons mentioned in this chapter, opened taverns in their homes where travelers could spend the night and dine on good food. Meetings, such as the first town meeting of Coventry, were held at the Braytons' home, now known as the Paine House. Men and women like Susanna and Joseph Bucklin, mentioned in this chapter, are representative of the great pioneer spirit that shaped America. Founding families of this area came from the colonies of Massachusetts, Connecticut, and other parts of Rhode Island.

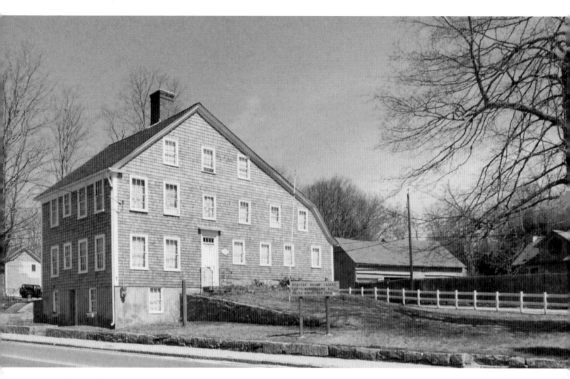

Families of the Paine House

The Paine House in Coventry is believed to have been constructed around 1689. Its history suggests that the house was owned by numerous families over the years but it derived its name from the last family that owned the home. Samuel Bennett, who also built a gristmill, is believed to have built the house. While he resided there, this section of Coventry became known as Bennettville. As there were very few structures in Coventry when it separated from Warwick, the first town meeting was held in this house. When Francis Brayton moved his family from Portsmouth to Coventry around 1749, he purchased Bennett's house and gristmill. Brayton eventually established a blacksmith shop and operated a tavern out of the home. As this building served as the center of the village, the village became known as Braytonville. Brayton's son Francis Brayton Jr. was granted a license to run the tavern. Charles Holden was the next owner and operator of the tavern, and the Holden family owned the structure until 1847, when it was sold to Thomas Whipple. His widow Sally Whipple sold the house to Mary Mathewson and Phebe Wood Paine, who were sisters. Phebe had two children, Herbert F. and Orvilla Paine. Mathewson sold her share of the house to Phebe Wood Paine Johnson, who, along with husband Philip Johnson, was the next owner. They had a daughter, Zilpha, who, along with her half brother Herbert and half sister Orvilla, became the owners of the house. Herbert Paine was the last resident of this house.

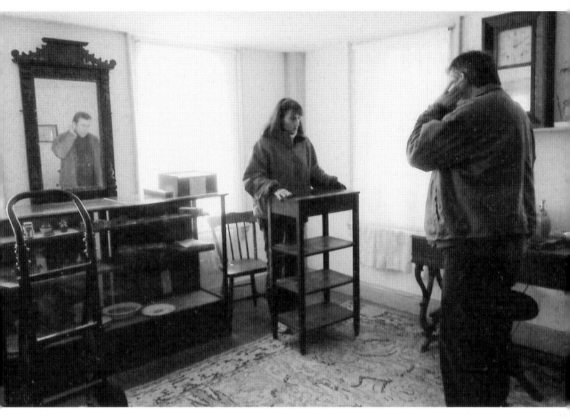

Brenda Jacob, President of the Western Rhode Island Civic Historical Society
Jacob, the president of the Western Rhode Island Civic Historical Society, is pictured here with volunteer Marc Gardner as they set up a research area for library patrons in one of the rooms. The Western Rhode Island Civic Historical Society was started in July 1945 and had been meeting in various locations prior to moving to the Paine House in 1953. This organization offers tours to school groups and the public. The museum, which houses collections of furniture and clothes, a fire engine, and photographs of buildings and residents, believes in educating the public on the history of Coventry through its newsletter, the *Hinterlander*.

Susanna and Joseph Bucklin
The Bucklins, who moved from Rehoboth, Massachusetts, to the frontier, represent the families that saw an opportunity to farm and raise a family on their own land. Joseph established a gristmill while Susanna took care of the family. Susanna died at the age of 36. Her slate gravestone was made by a local carver named Jonathan Roberts and is one of the earliest in Coventry. Her husband was one of the signers of the petition to form the town of Coventry.

15

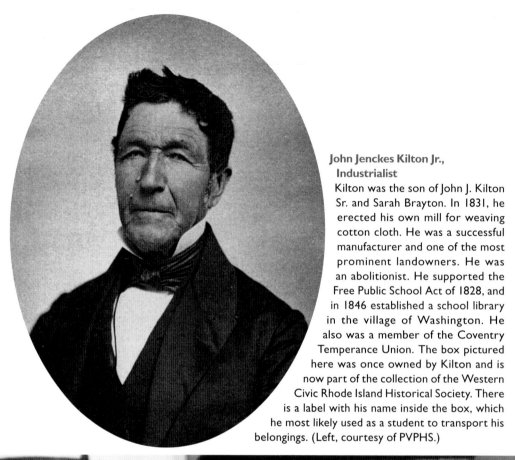

John Jenckes Kilton Jr., Industrialist
Kilton was the son of John J. Kilton Sr. and Sarah Brayton. In 1831, he erected his own mill for weaving cotton cloth. He was a successful manufacturer and one of the most prominent landowners. He was an abolitionist. He supported the Free Public School Act of 1828, and in 1846 established a school library in the village of Washington. He also was a member of the Coventry Temperance Union. The box pictured here was once owned by Kilton and is now part of the collection of the Western Civic Rhode Island Historical Society. There is a label with his name inside the box, which he most likely used as a student to transport his belongings. (Left, courtesy of PVPHS.)

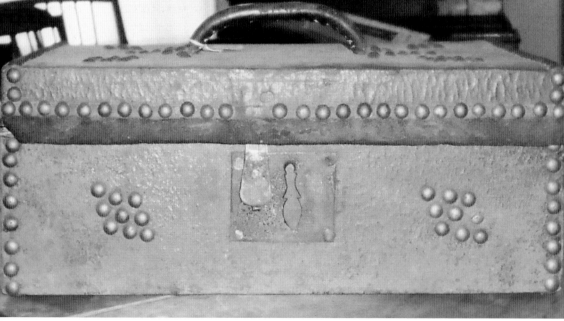

CHAPTER THREE

Let Me Entertain You

Taverns, like the Brayton Tavern owned by Francis Brayton Jr., were used as social meeting places in the early days of Coventry; today, there are 49 different restaurants in which to socialize in town. During the time that the Showboat was in business, Coventry had many restaurants, bars, and clubs, but not another one looked liked an ocean liner and was run by a former wrestler. Families would have birthday parties, weddings, and wedding receptions in this establishment, and organizations such as the Order of the Elks, the Republican Party, and the Democratic Party would hold meetings in the restaurant. The Showboat and Alphee Bleir were a big part of the life of all Coventry residents, particularly in supporting local sports teams. This establishment was so well remembered—not only by Coventry residents but also by outsiders—that the image of the Showboat was made into a Christmas ornament for the Pawtuxet Valley Preservation and Historical Society to sell. The Maple Root Inn, owned by Albert Pastille, Harry Carlson, and James DeMarco, was another dining establishment that was frequented by locals as well as outsiders from the 1920s to the 1970s.

In the past, families in Coventry went to the two movie establishments in town; one was the indoor Jerry Lewis Theatre, and the other a drive-in movie theater. The 1970s Jerry Lewis Theatre is now used as a restaurant called the Olde Theater Diner, currently owned and operated by Louie and Nico Zarakostas. For a quieter form of entertainment, Coventry has a new/used bookstore—All Booked Up, owned by Deana Borges—where one can find local authors signing books and holding discussions.

Coventry families have had a variety of special events to attend, like the Randall Card Circus that was held in the 1930s, Coventry Old Home Days in the 1940s, and Coventry Pride Days in the 2000s. Nearly every day a sports league for children and adults can be found at the Coventry Recreation Center, and many activities for the town's senior citizens are held at the Coventry Senior Center. Many of these and others are the focus of stories gathered from the people of Coventry and included in this chapter.

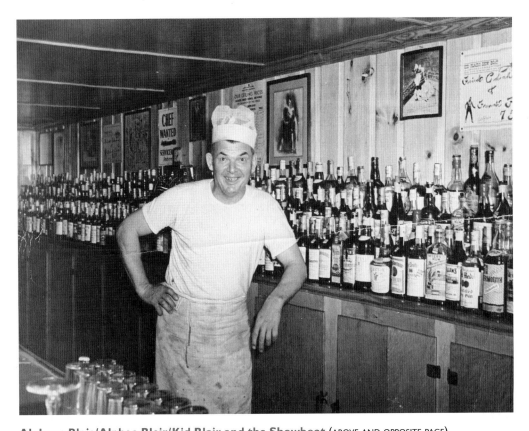

Alphege Blais/Alphee Bleir/Kid Blair and the Showboat (ABOVE AND OPPOSITE PAGE)

The Showboat Restaurant was a boat-shaped building constructed in the 1920s along Arnold Road in a section known as Little Tiogue. Opalma Blais bought it, and Alphege Blais—her husband, who was born in Saint-Alexandre, Quebec, Canada—became the new owner. Blais was orphaned at the age of 14 and joined a lumber camp until the age of 21. He then joined the service, serving as a cook at Camp Devens during World War I. This is where he became interested in wrestling. During his wrestling career, he became known as "Kid Blair" and joined the traveling Jim & Benson Carnival, which brought him to New England and Rhode Island. In Rhode Island, he wrestled in a match in Coventry and met his future wife, Opalma Jacques, who caught his robe when he threw it off. After the match when he retrieved his robe, he talked with her, and he later married her on January 25, 1924. When the carnival moved on, Blais remained behind, operating the Log Cabin restaurant in Arctic, managing the Kent Brewing Company, and eventually purchasing the structure that would later be called Kid Blair's Showboat.

The story goes that Kid Blair had Tiogue Lake drained, and according to Coventry resident Norma Smith, her grandfather Hector Poulin was hired to drive his truck to tow the boat across the lake bottom to the eastern shore of Lake Tiogue. According to an April 1933 newspaper article titled "Here Comes the Showboat, Here Comes the Showboat," a boat had been near the levee on Little Lake Tiogue, and they had planned on moving it across the lake on ice, but the lake never froze. The newspaper stated, "It will be moved over land about 1000 feet with the help of rollers." No matter how it actually happened, it was moved and set up and functioned as a dancing and eating establishment from the late 1930s until it was destroyed by fire in 1976. This restaurant was so well known that more than three decades later, the mere mention of the name Kid Blair or the Showboat to people of a certain age causes their eyes to light up and the stories to come out. (Both, courtesy of PVPHS.)

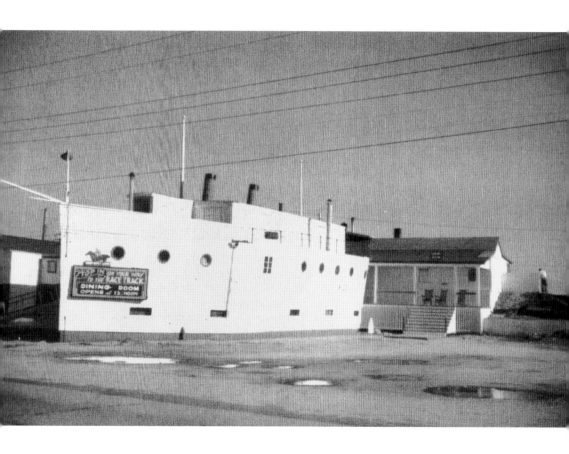

Warners of Coventry (OPPOSITE PAGE)
George Warner opened Warner's Rustic Inn on October 26, 1926, along Route 117 near Alvero Road in Coventry. The foundation of the building and the establishment's rustic tables were made of the logs cleared from the land. The people of Coventry went there to enjoy the live bands and dances. After Warner's death, the restaurant passed to his sons Harold and Earl Warner. Harold, the only graduate of the 1926 class of Read School House, and Earl operated the restaurant until 1974. For many years, the Warner family sponsored Coventry sports teams, such as bowling, golf, and softball. The inn was known for its clambake shed, games, and prizes. (Courtesy of PVPHS.)

The Married and Single Men's Baseball Team
The Married and Single Men's Baseball Team, sponsored by Lavigne Construction, is pictured at its first annual outing at Warner's Rustic Inn on August 21, 1927. Omer Lavigne, a senior partner at O&S Lavigne Co., is among the players. (Courtesy of PVPHS.)

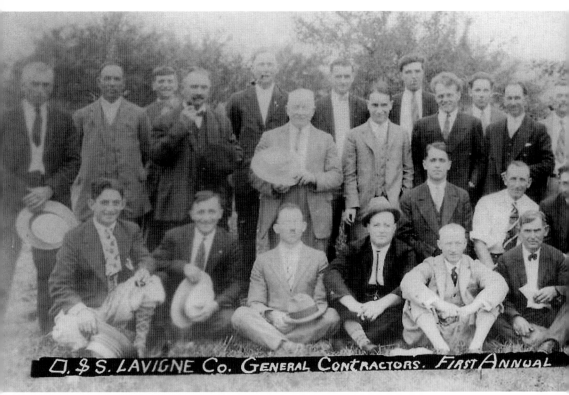

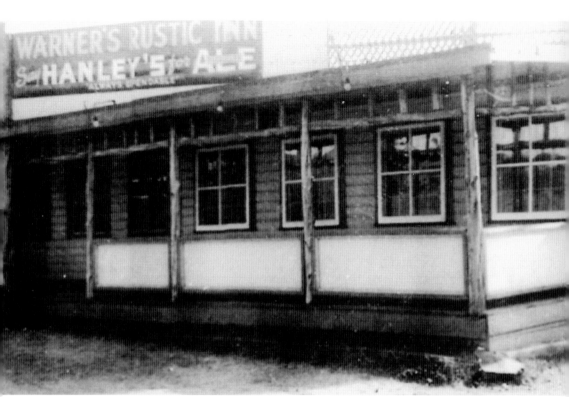

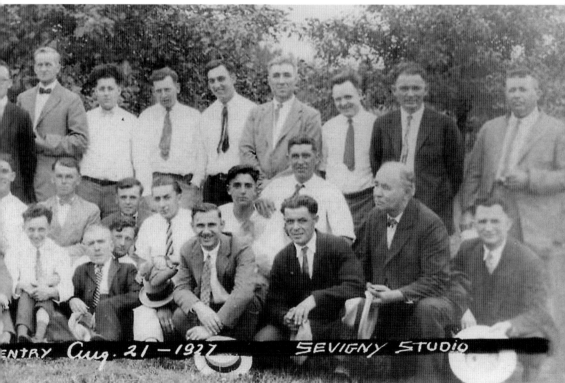

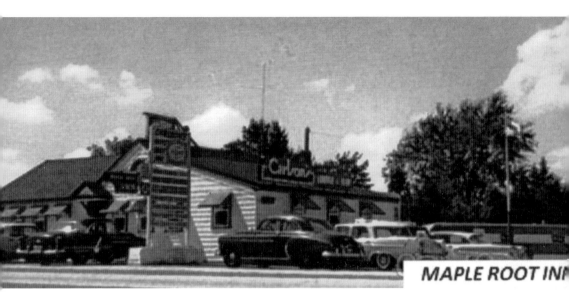

MAPLE ROOT INN

The Maple Root Inn

The Maple Root Inn was a family-owned restaurant that was open seven days a week at the intersection of Harkney Hill Road and Tiogue Avenue (Route 3). It was first owned and operated by Albert Pastille and his wife, Mary, who was a waitress in the restaurant. In 1945, Pastille sold the Maple Root Inn to Harry and Hazel Carlson, who then named it Carlson's Maple Root Inn. The Carlsons sponsored trips to Fenway Park for the children of Coventry to see the Boston Red Sox. Carlson sold the restaurant in 1969 to James DeMarco. To this day, Coventry residents and others often reminisce about the dinners they had there, such as boiled or broiled stuffed lobsters, steaks, chops, and seafood. (Courtesy of PVPHS.)

Louie and Nico Zarakostas, the Olde Theater Diner

Louie (left) and Nico Zarakostas, father and son, are the owners of the Olde Theater Diner. When Louie was asked what kind of restaurant he wanted, his reply was, "a successful one," and it appears he has been very successful. He has been in the restaurant business for 30 years and has opened 20 restaurants that are all still operating today. In 2010, he opened the Old Theater Diner in Coventry in the building that had been the Jerry Lewis Theatre in the early 1970s. The family-style restaurant is based on the design of the old movie theater, which is a treat to his customers as many of them remember going there on dates when it was a cinema.

Henry Viens

Viens (third from left) was born Henrio A. Viens in Rhode Island to French Canadian parents. He is representative of the American dream. His family came to the United States in hopes of a better life, and a good life he had. He worked as a chauffeur and an insurance agent and opened United Solicitians, which was a burial company. Viens participated in Old Home Days and was a member of the Coventry Chamber of Commerce. He petitioned the town council to open a dining car in 1946 but instead acquired the Tiogue Vista, which he ran with a business partner. The Tiogue Vista had live music and a function hall that residents used for weddings, baby showers, and other gatherings. Viens generously offered the use of this hall to numerous organizations for free. He also held Mystery Rides, which were very popular at that time, in which one person would drive others to a surprise destination. Today, this restaurant is known as Nino's on Lake Tiogue. (Courtesy of CHS.)

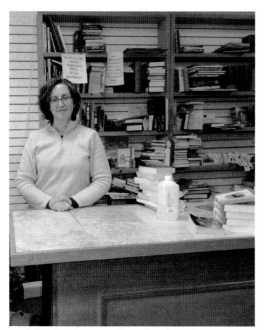

Deana Borges, All Booked Up
The new/used bookstore All Booked Up has been in Coventry only three years, and is the only bookstore in Coventry. Deana Borges is the owner and sales clerk. The farthest away she has ever had to send a book was Antarctica. The business has participated in Operation Paperback, a program that collects books to send to troops overseas. Borges was surprised when she received a letter back from a soldier saying, "thank you." Borges hosts a book reading group as well as book signings for local authors, and has developed friendships with many local residents.

Stamatis Karapatakis, Gelina's Ice Cream
Karapatakis emigrated from Greece to the United States over 20 years ago and began working in the restaurant business in Rhode Island. Steve, as he is known, currently owns and operates Gelina's Ice Cream, where many Coventry families can be found sitting at outdoor tables on hot summer evenings enjoying a wide selection of ice cream. Since 1982, Coventry residents have been enjoying ice cream at Gelina's.

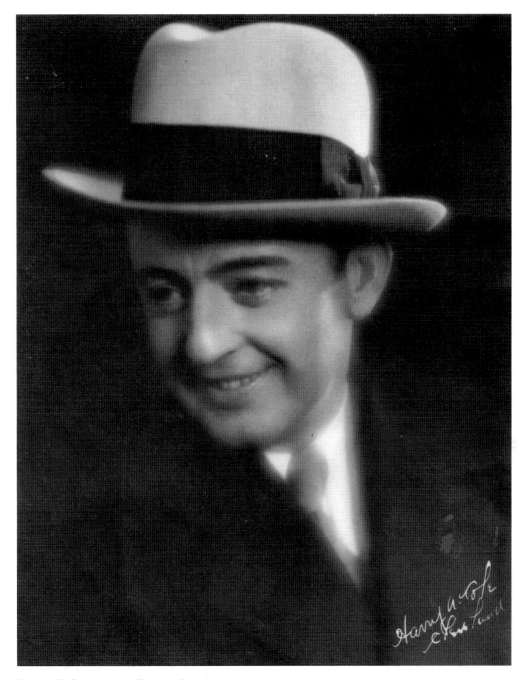

Danny P. Cavanaugh, Entertainer
Cavanaugh of Coventry was born in August 1893 to Daniel P. Cavanaugh and Catherine McKenna and was married to Florence Clean. Before he moved to New York, he worked in various manufacturing companies and sang at local theaters. He was a veteran of World War I, where he sang and entertained the troops. In 1940, he lived in Manhattan and worked as a radio star and actor. He was known as the Ave Maria Tenor. In honor of the 200th anniversary of the founding of Coventry, the town had him perform. He died November 22, 1960, in Hollywood. (Courtesy of PVPHS.)

Randall T. Card, Showman

Card (fifth from right below) was 74 years old when he began his own circus in the style of P.T. Barnum and Buffalo Bill Cody. Card's working life began when he was just seven years old at the John Jenckes Kilton Mill in the village of Washington. His interest in show business came from his stepfather, Professor Potter, a sleight-of-hand performer who performed with local legend Prof. Benjamin Sweet. Card would have seen Sweet perform feats such as walking a tightrope across the Pawtuxet River. Card had his own marionette show, and around 1880 he opened a Barney Chambers museum, which was a traveling museum attached to a wild west show. In his lifetime, he was a stage performer in many shows, including *Around the World in 80 Days*. During the downtime when the show was not out performing, Card clammed and fished along Oakland Beach and provided clams to Charlie Maxwell, who owned Rocky Point. He began his own circus with a dog-and-pony show during the Great Depression and eventually had a big top that could seat 800 people. He worked all aspects of the circus, including cutting tent poles from trees on his own property. His circus traveled around Rhode Island, Massachusetts, and Connecticut in a caravan of vehicles with the name of the show painted on the side. When not on the road, he kept the circus on the old Salisbury Farm. His son George worked as the equestrian director, while his daughter and son-in-law operated the candy concession. His featured performer was Jennie, a rhesus monkey. (Both, courtesy of Donald Card.)

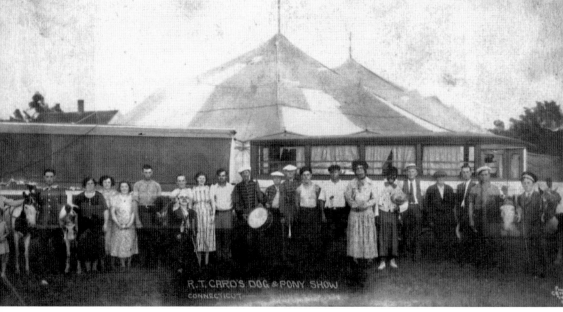

CHAPTER FOUR

Bravery on the Battlefield

Coventry residents have answered the call of duty since the 1600s, and many have made the ultimate sacrifice for their neighbors and country. Two men mentioned in this chapter are representative of the 500 men of Coventry who served during the Civil War. One man received the Medal of Honor for his actions during the Civil War siege of Petersburg, Virginia, on April 2, 1865. The residents of Coventry also formed a local militia company during the Civil War and leased space in Pardon S. Peckham's building to train men and store arms. Four men are known to have enlisted in the Army during the Spanish-American War. Men from the area also served in World War I, and in this chapter their lives will be highlighted. During World War II, the people of Coventry raised money to support their sister city in England, which had been bombed during the Germans' attack on England. On August 14, 1950, the town of Coventry dedicated the World War II memorial located in front of the Coventry Police Department in honor of the men and women from the town who served in the war. Following the examples of their brothers and fathers, many men—including Robert Phillips, Everett Hudson Jr., and Philip St. Jean—enlisted in the armed services and served overseas as well as stateside in Korea and Vietnam. Coventry High School has an ROTC program, and many young people, like Corey O'Connor, have benefited from this program and gone on to pursue careers in the armed forces.

Post September 11, 2001, Coventry residents have continued to follow the example of these brave soldiers by serving in the Rhode Island National Guard and the US armed forces. Just as during World War II they would put up an honor roll listing the men and women who were serving overseas, Coreen St. Jean, Corey O'Connor's mother, created a monument to the men and women who were serving during Operation Iraqi Freedom.

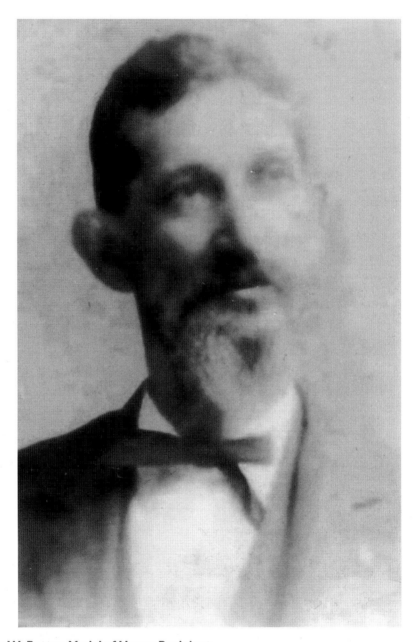

George W. Potter, Medal of Honor Recipient
Potter received the Congressional Medal of Honor on March 4, 1866, for his bravery in the Civil War. Potter, born in Coventry on December 11, 1843, was a single, 18-year-old farmer before enlisting in Providence in the Union army. During the siege of Petersburg, Virginia, he was shot in the left temple and lost sight in his left eye. After discharge, he worked for the railroad as a section hand and was married to a woman named Susan, with whom he had a son named William F. Potter. Potter died at the Soldiers Home in Bristol on November 30, 1918, and is buried in the North Burial Ground in Providence. His citation reads that he "was one of a detachment of 20 picked artillerymen who voluntarily accompanied an infantry assaulting party and who turned upon the enemy the guns captured in the assault." (Courtesy of Robert Grandchamp.)

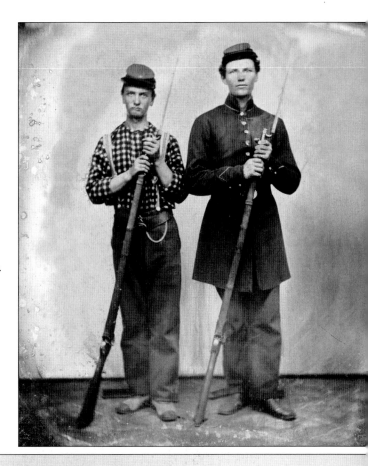

William Carr Rathbun and Oliver Brown

Another brave soldier, Rathbun (right) was one of three brothers from Coventry who enlisted in Company H 7th Rhode Island Infantry at the start of the Civil War. During the Battle of Fredericksburg, he lost his right foot saving his friend Oliver Brown. He returned from the war to West Greenwich and became a farmer. He moved his family to Coventry in the 1880s to a farm located along South Main Street, and the house he lived in still stands today. He was the father of five daughters who all became schoolteachers. (Both, courtesy of Rachael Pierce.)

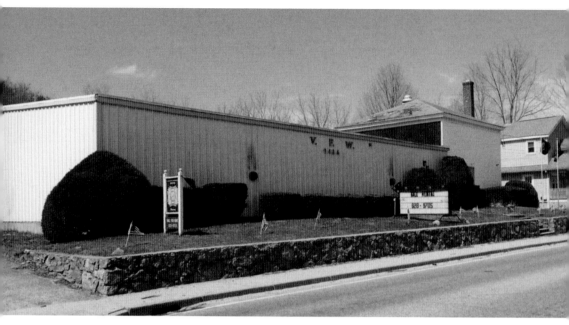

Veterans of Foreign Wars Coventry Memorial Post No. 9404
Veterans of Foreign Wars Coventry Memorial Post No. 9404 was built in 1950 and has served as a meeting place for veterans of the Coventry community. The mission of the organization is to promote patriotism and community service. This post hosts events each Memorial Day and Veterans Day in addition to other holiday events for military and community families.

George B. Sprague, Charles A. Patterson, James T. Hill, and Edward Essex
This Spanish-American War gravestone marker is representative of the markers on the graves of the four Coventry men who served during the conflict. George B. Sprague and Edward E. Essex were both members of the 1st Rhode Island Volunteer Infantry; Sprague was a member of Company B, and Essex was a member of Company C. Both died October 17, 1898. Charles A. Patterson and James T. Hill survived the war.

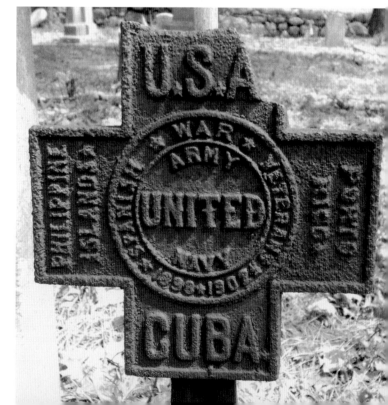

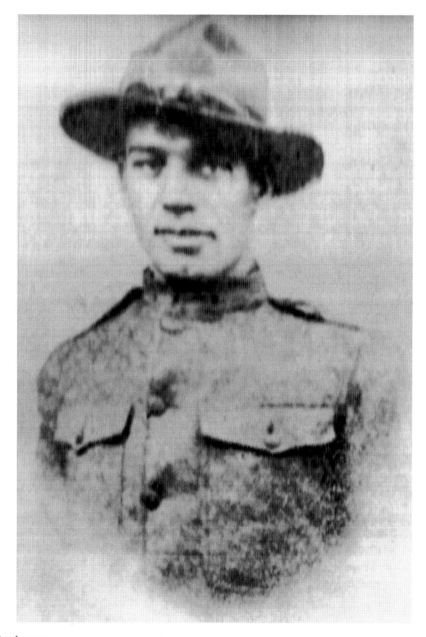

David Papineau
Papineau was a French Canadian American who was born July 9, 1888, in the section of Coventry known as Anthony. His parents were Antoine and Victorine (Loiselle) Papineau. He enlisted in the Rhode Island National Guard on June 11, 1917, and was a member of Battery C 1st Battalion, 103rd Field Artillery. When his unit was shipped overseas in November 1917, they became attached to the American Expeditionary Force. He was mortally wounded July 19, 1918, at Château-Thierry—just 10 days after his 30th birthday—and is quoted as saying "Take care of Johnnie first. His wound is far worse than mine." He was originally buried overseas, but his body was returned to the Pawtuxet Valley for burial in 1921. As a result of his sacrifice, the town of Coventry named an American Legion post after him. (Courtesy of PVPHS.)

George Washington Andrews

Andrews was born June 1, 1893, and worked at the Interlaken Mill. He served in the American Expeditionary Force during World War I and was shot in the head during the battle of St. Mihiel in the Argonne Forest in France in September 1918. After the war, he returned to Coventry and was employed as a security guard at the Centerville Bank for 33 years, and was credited with foiling a robbery. In April 1946, he helped the Coventry police apprehend two youths who had stolen a car. The youths had stopped along Nooseneck Hill Road near Andrews's house to change a flat tire. When they could not open the lock on the car, they went to Andrews to borrow a hammer and screwdriver. Something about them aroused Andrews's suspicion, so he called the police, who quickly came and arrested the youths. Andrews had a nephew named Daniel George Wood who died in World War II. Andrews died in 1964. (Courtesy of Rachael Pierce.)

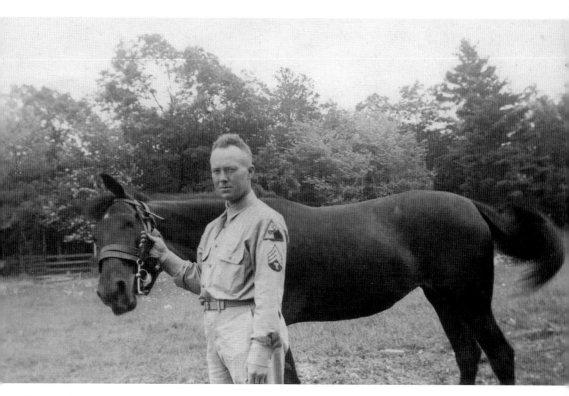

Daniel George Wood and Trixie
Wood was born in Coventry and served in the 3rd Armored Division during World War II. His sister recalled how he loved his horse Trixie and hated to sell her before he left for the service. He was one of 35 causalities from Coventry. He was killed in action during the Battle of the Bulge. He was buried overseas, and his body was later brought back home to be interred in the family cemetery in Coventry. In honor of his service, the town of Coventry named Wood Street after him. (Courtesy of Rachael Pierce.)

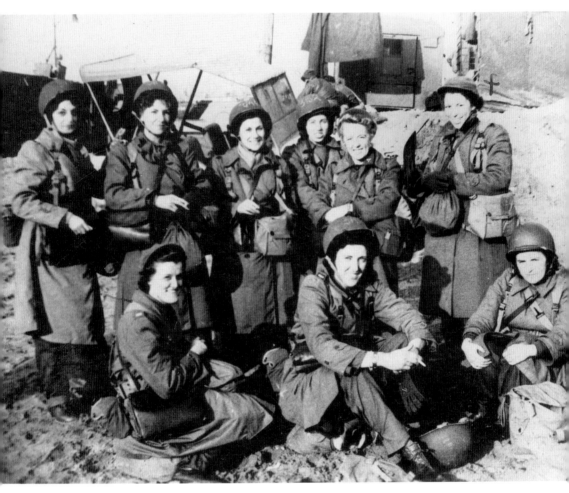

Mary Agnes Delehantey, Army Nurse
Delehantey (first row, left) was a first lieutenant US Army nurse. She was born February 3, 1921, in Vermont but moved to Coventry when she was nine years old. She graduated from Coventry High School and attended nursing school. She was one of 20 women from Coventry who served in World War II, and her name was added to the Honor Roll dedicated on August 14, 1950. After the war, Delehantey worked at South County Hospital and lived in Wakefield until her death on May 13, 2009. She is buried in the Rhode Island Veterans Memorial Cemetery in Exeter. (Courtesy of Rachael Pierce.)

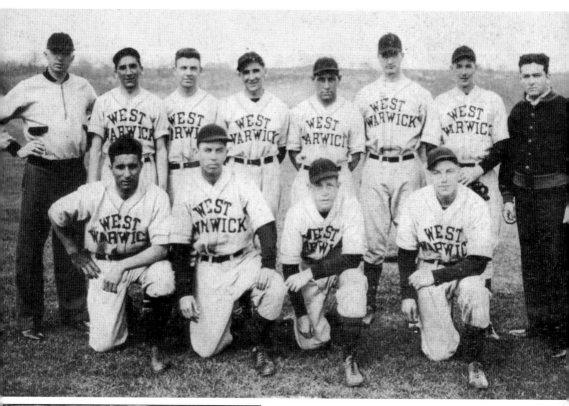

Richard Hudson, Professional Baseball Player

Hudson (second row, second from right), a Coventry native who graduated from West Warwick High School in 1934, was drafted to play professional baseball for the Cleveland Indians in 1937. He played for various farm teams before enlisting in the US Army and serving in World War II, where he saved a fellow soldier's life after the soldier fell in a hole. (Courtesy of Rachael Pierce.)

Arthur Dubuc, World War II Civilian Contractor

Dubuc was a civilian contractor during the Aleutian Islands Campaign of World War II. He was born in Bristol on May 16, 1913, and died August 5, 1990. During his lifetime, he worked for Aetna Insurance, Electric Boat, and US Rubber. After his marriage to Grace Smith, they moved to Coventry. He was a secretary for the Coventry West Greenwich Elks. (Courtesy of Norma Smith.)

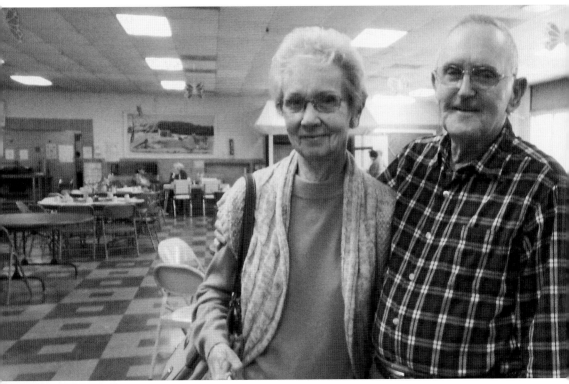

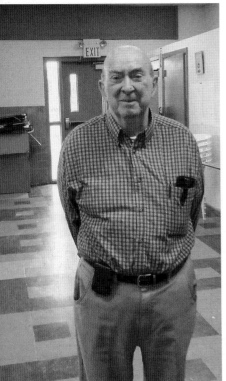

Robert and Tillie Phillips, Volunteers
The Phillipses are both volunteers at the Coventry Senior Center. Robert, who had 10 siblings, moved to Abbotts Crossing in Coventry at the age of seven. He entered the 145th Infantry Division in the US Army around 1951 and served in Korea. He earned a Purple Heart, a Bronze Star, and a Combat Infantryman Badge. Upon returning from the war, he worked for his father at Phillips Garage in Coventry.

Bob Amaral
Amaral worked for Acme Laundry (now known as Falvey Linen) in West Warwick and for many years provided laundry service to his father's nursing homes in Coventry. Amaral played in the dance band at the Showboat, served in Korea, played the drums, and was a member of the Portuguese Marching Band. Today, he is a volunteer at the Coventry Senior Center.

Everett Hudson Jr.
Hudson served as a driver for a lieutenant colonel when he was stationed at Pusan, Korea, in the 863rd Transportation Company in the US Army. When he returned home, he worked as driver for Suburban/Phillips Propane Company. Like his father and mother, he was active in the Republican Party in Coventry and served on the town council. (Courtesy of Everett Hudson Jr.)

ELECT
EVERETT E. "JUNIOR" HUDSON
"A NATIVE SON"

FOR
TOWN COUNCIL DISTRICT 2

Special Election

TUESDAY OCTOBER 18

REPUBLICAN

Philip St. Jean
St. Jean served during the Vietnam War in the US Army. He worked as a battalion mail clerk at headquarters, and one of his jobs was to sort the mail containing the notifications of causalities for his unit. After his service, he returned to Coventry and today operates a transmission repair shop—the Transmission Shop—with his sons.

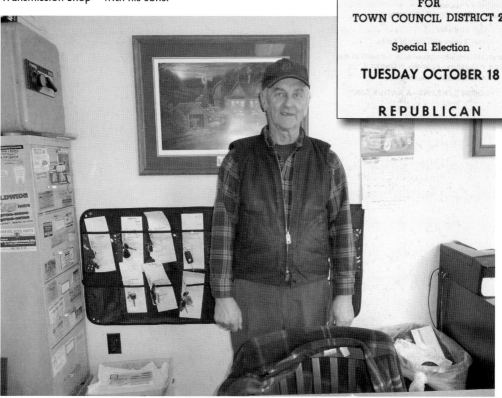

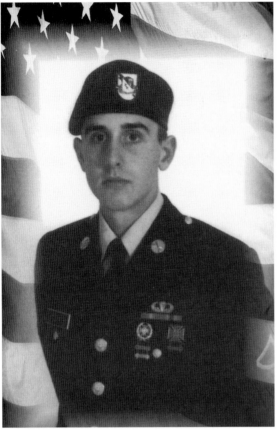

Corey O'Connor

O'Connor was a member of the Reserve Officers Training Corps when he was a student at Coventry High School. After graduation in 2001, he enlisted in the US Army and served in the 82nd Airborne Division. He was one of a group of friends who all enlisted in different branches of the service around the same time. Upon completing basic training, he was deployed to Iraq. O'Connor served two tours of duty in Iraq. During his service, his mother, Coreen, and his stepfather, Philip St. Jean, approached the Coventry Town Council and proposed the idea of a board located outside the Coventry Recreation Center to highlight the service of men and women from the area. The town approved, and, through volunteers and donations, the board was completed and named Coventry's Bravest. Pictured below is O'Connor's home decorated for his return. (Both, courtesy of Coreen St. Jean.)

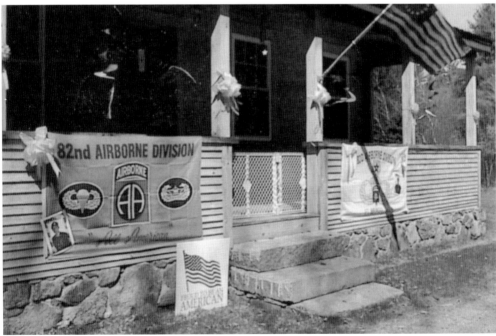

CHAPTER FIVE

Lumber, Lace, Stores, and More

The founders of Coventry began gristmills and sawmills. As the Industrial Revolution began and progressed, textile mills and machine shops took their places. Then, the arrival of the railroad in the 1850s changed the economic structure of Coventry. The ability to transport goods to larger cities improved the economy of the area. Coventry became home to two quarries, which provided jobs for many. By the turn of the 20th century, the cotton- and wool-manufacturing companies moved south, leaving a void that would be filled by local residents who started lace mills and employed many of the skilled textile workers. These include Joseph Maguire of Maguire Lace & Warping and Jack Beattie of Beattie Lace. Lace produced in one of these textile mills appeared on dresses worn by Miss America and Dale Evans as well as on the clothing of local residents.

The men and women in this chapter saw opportunities to establish small shops and family businesses as their ancestors had. They played such important roles in the history of the town that streets were named for them. Today, the core of Coventry's economy is based on family-run businesses, just as it always has been. In this section, readers will discover Searles Capwell, who is known for his lumber mill, and Hector Poulin, who not only ran a mill but also moved the Showboat. Coventry has cleaners, printers, hairdressers, grocers, and web designers, as well as small shops—such as the Krafty Sisters, providing residents with handmade crafts, or George Proffitt's and Gregory Iannotti's floral businesses, providing flowers for proms, weddings, and funerals (such as those held at the Gorton Menard Funeral Home, now located in the former Byron Read homestead). For local news in the early days, one would head down to Everett Hudson's well-known Hudson Store. Today, residents can go to Skaling's Summit General Store or to Veterans Market. And, for that occasional Cinderella-like experience, there is no place like Bruce and Rosemarie Guertin's Magical Affairs.

Searles Capwell, Mill Owner and Politician

Capwell (above right, with daughter Nettie Northop and granddaughter Lois Alice Northop) was born in West Greenwich, Rhode Island, on April 8, 1838, and died October 2, 1916. He married twice—the first time to Susan D. Greene and the second time to Florence E. Briggs. He owned a lumber mill and served as a politician from Coventry. Capwell set up his Sash, Doors and Blinds mill in the mill complex that had been the Perez Pecks Machine Shop, which had provided machinery for the textile mills. The Capwell house was constructed on Main Street in Anthony, not far from Capwell's mill. Capwell lived in this Queen Anne–style house with his wife, Florence, and the architectural details of the structure show the wealth of the owner. Currently, it has been divided into apartment units. (Above, courtesy of CHS.)

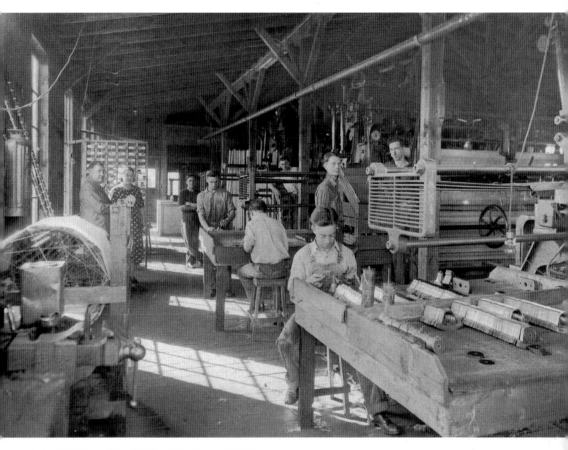

John William "Jack" Beattie, Lace Mill Owner
Coventry was once known as the lace capital of the United States. Jack Beattie was born in Long Eaton, England, on January 10, 1892, and was the owner of Beattie Lace Works, located along Hopkins Hill Road in Coventry. This image shows Beattie (far left), his daughter Irene Beattie (beside him), and several unidentified workers inside the mill. These mills produced a product called "leavers lace," which is a fine, delicate pattern that resembles handmade lace. The first laceworks in Coventry was Washington Lace Works, which was formed in 1929 by Charles Thompson and George Clarke. In 1951, Coventry was home to 24 lace companies, and the Linwood Lace Mill, the Washington Lace Works, the Mruk Lace Mill, and Beattie Lace Works were all active there at one time. There were 428 lace machines in operation in 1963. (Courtesy of CHS.)

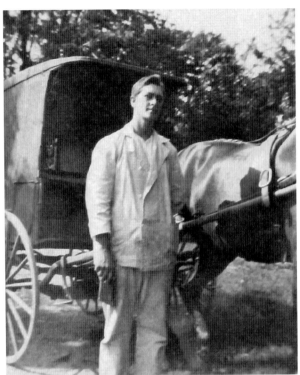

Charles William Whitford, Salesman

Whitford was known as "Wil" in this small, tight-knit community. He worked in Benoit's Market (pictured below), where people went to vote, went to Knotty Oak Baptist Church, and walked to work. His father-in-law was Philip Johnson, a Boston Post Cane Recipient, and Whitford was the grandfather of J. Francis Remington, a well-known police officer. As a grocery clerk, Whitford delivered goods to people's homes by horse-drawn wagon. (Left, courtesy of Lois Sorenson; below, courtesy of PVPHS.)

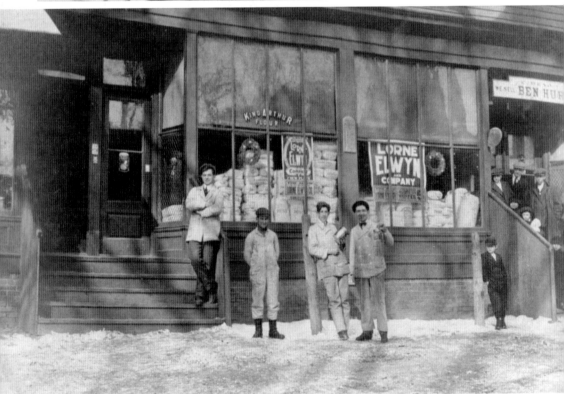

Everett E. Hudson Sr., Businessman
Hudson owned and operated the Hudson Store along Main Street in the village of Washington from the 1930s through the 1960s, when the building was bought and moved into the new shopping plaza. The store would open early in the morning so the men and women on their way to the factories could buy a newspaper. Children also stopped by on their way to and from school to buy penny candy. Hudson served as a senator from Coventry and was active in the Coventry Republican Party. He was known as "Boots" among his friends.

43

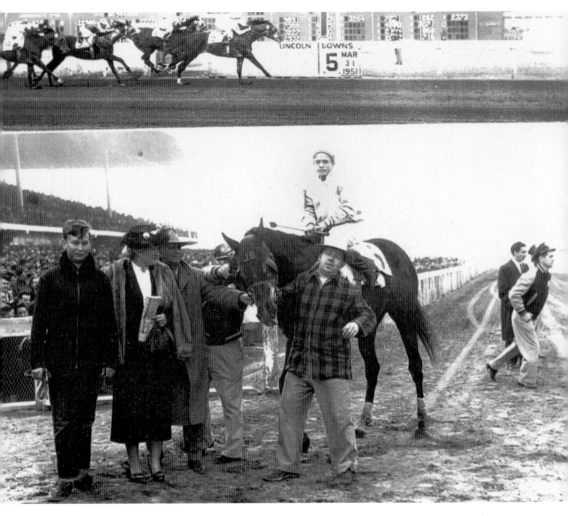

William James "Jim" Beattie, Racehorse Owner

Beattie was born February 23, 1890, in Derbyshire, England. He was the treasurer of Linwood Lace Mill and also owned a stable of racehorses. In October 1959, one of the barns located on his horse farm burned to the ground, killing 17 of the 21 racehorses that he owned. The only reason four horses survived was that Pat Patterson and Beattie ran into the burning barn to save them. This was not the first time tragedy struck Beattie: his first wife had died, and his son-in-law and business partner, who had flown missions as a fighter pilot during World War II, had succumbed to a fatal disease the previous year. But Beattie vowed to rebuild the barn and to continue racing horses, which he did. Beattie died on July 11, 1969, on the *Queen Elizabeth* cruise ship traveling to visit the old sod of England. In this image, Beattie is third from the left, Augustus Hutchins is the horse handler in the plaid shirt, and the boy at left is his son George Hutchins. The horse was Linwood Harry. (Courtesy of the Hawkins family.)

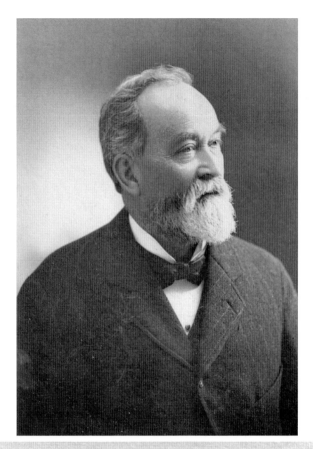

Horace N. Foster, Violinist, Engineer, and Surveyor
Foster was a violinist as well as an engineer and surveyor in the Anthony section of Coventry. He constructed many buildings and homes in the town. He was born September 15, 1836, and died December 23, 1928. He was married to Sybil W. Read. A talented violin player, Foster could play and entertain guests as well at the age of 90 as he could when he was 40 years old. He was active in the Anthony Grange, which was named after the village of Anthony, which in turn was named after Daniel Anthony, the founder of the village. The Grange had a hall that was used by residents for political get-togethers and social events, and Foster provided this organization with music. Guests were quoted as saying, "Horace plays a wicked bow." (Both, courtesy of CHS.)

H. N. FOSTER,

ENGINEER & SURVEYOR.

Anthony R. I.

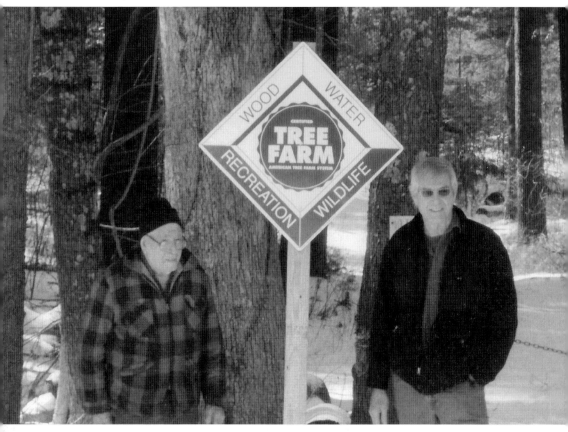

Joseph Maguire, Mill Operator and Tree Farmer (ABOVE AND OPPOSITE PAGE)
Maguire Lace & Warping Mill, located at 65 Stone Street, is owned and operated by the Maguire family. The company was started in 1951 by Joseph Maguire, and he remains at the helm today with his son James alongside him. Maguire, who is a spry 90-something, is still operating the looms and fixing the broken threads, just as he has done since he began the trade as a younger man. This laceworks, one of three operating in Coventry, represents a dying industry. It provides lace to the stores of New York, and its product has appeared on dresses worn by Miss America and Dale Evans. Joseph Maguire owns many acres of wooded property in Coventry and was awarded the Rhode Island Tree Farmer of the Year award in 2009. (Above, courtesy of Rhode Island Foresters Conservators Organization.)

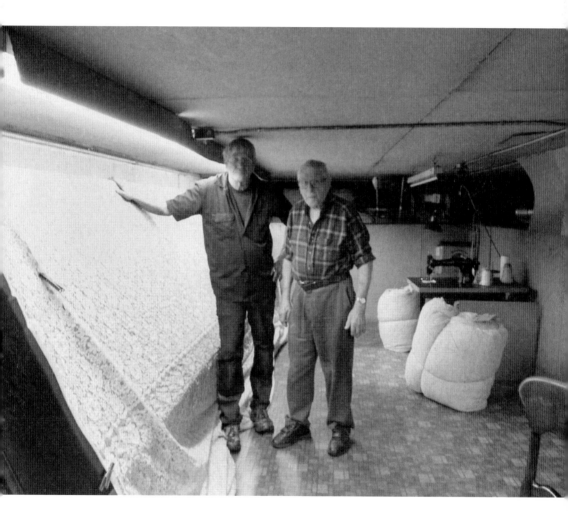

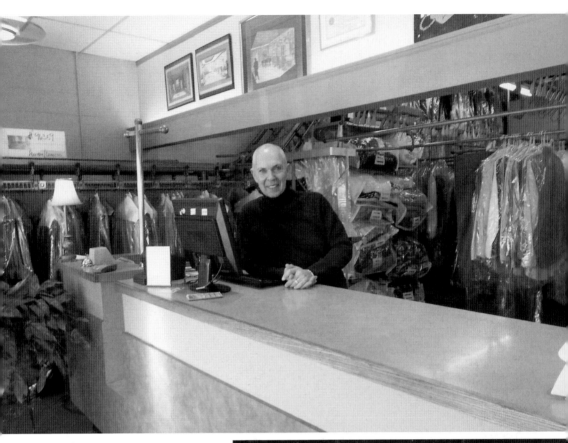

William and Leslie Marcotte, Businessmen

Crystal Cleansers was started by Leslie Marcotte (right) in 1946 at 157 Main Street. Marcotte also helped to establish the Coventry Credit Union, which stood across the street from the dry cleaners and now has two locations in town. Crystal Cleansers represents one of the many family-owned businesses that make up the backbone of the town's economy. The Coventry Shoppers Park, where Crystal Cleansers is located today, opened in 1965 on the site of the first dry cleaner. On display in the shop is an original advertising sign that was placed in Leslie Marcotte's Volkswagen when he made deliveries. Leslie's son William Marcotte (above) is the current owner. (Right, courtesy of CHS.)

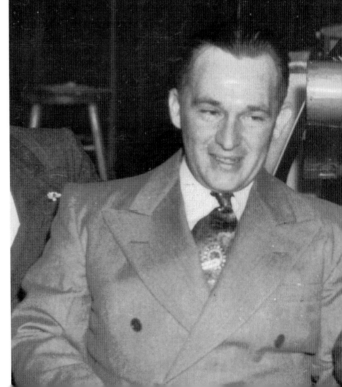

George Proffitt, Sailor and Businessman

The Anthony School House and an icehouse were originally located on the property that now houses Ice House Flowers. Ice House Flowers, at 655 Washington Street, was founded in 1974 by George Proffitt. Before he started the business, Proffitt had served in both the Army and the Navy. During his stint in the Army, he was part of a unit sent to help rebuild Japan and was called up to serve in Korea when the war broke out. He transferred to the Navy, became a member of the Naval Criminal Investigative Services, and was stationed in Rhode Island. His introduction to the flower business happened when he was doing a background check on a US Marine. He visited a local florist shop looking for the Marine's brother-in-law and struck up a conversation with the owner. After his retirement from the Navy, he started selling flowers from the side of the road. As time passed, he was able to rent a building that had once housed the Anthony Sporting Shop. When he moved into the building, there was no running water, and he had to haul water from the pond to water the plants. The name of the company was derived from the fact that the structure had been the old icehouse. Proffitt has provided the Coventry community with flowers for weddings, funerals, and special events, and the flowers used in these arrangements come from places like Thailand, Ecuador, Colombia, and California. The business suffered a devastating fire in August 1981, but Proffitt stayed open, rebuilt, and still serves the community today. Over the course of his career, one of the major changes he has noticed in the floral business is the decline in elaborate arrangements because of changing funeral practices.

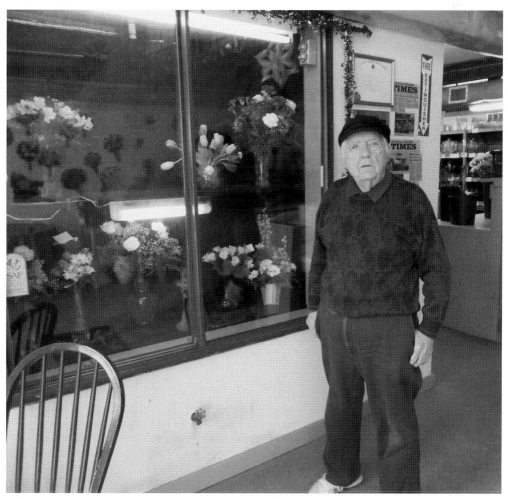

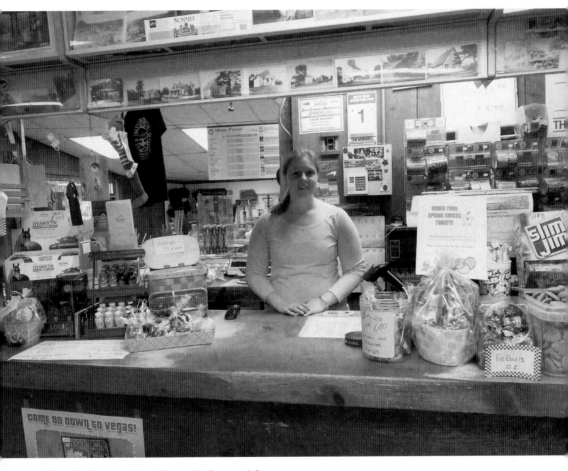

Kim Skaling and the Summit General Store

Skaling is shown here in the Summit General Store where she has been working since the age of 14. The Summit General Store was established in 1969 by her great-grandfather William Skaling and has been a family owned and operated store for three generations, selling everything from food to clothing to farm supplies. The store, which is located along the trestle trail near the site of the old railroad storehouse, serves as the center of the community. In the summer, residents can be seen stopping by to pick up their orders of smoked ribs, newspapers, or last-minute items. Skaling's father is one of the current owners of the store.

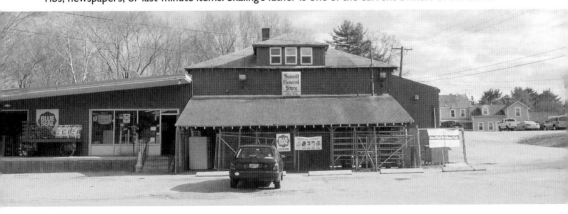

Gail Holland, Realtor

Being a Coventry native has prepared Holland to help people find not just a home in Coventry, but a place to establish their roots. As a real estate agent for Keller Williams, she provides her clientele with historical background, insight into the community, and her sense of Coventry pride. Holland especially enjoys working with first-time home buyers, some of whom were raised in Coventry. Holland's father worked for the L&M Lace Mill in Coventry, and her brother worked at the Showboat restaurant. When she was young, her father brought home pink lace from the mill, and her mother made her a dress that she wore for the Little Miss Natick Pageant. Over the years, Holland has witnessed the economic impact on Coventry housing in good times and in bad, but, being a true Rhode Islander, continues to maintain the hope for better times ahead since the downturn of the 2000s.

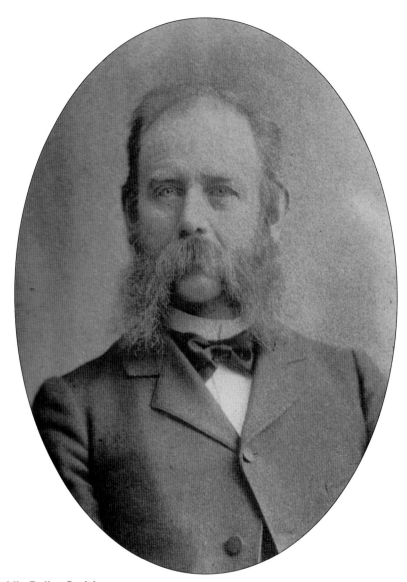

Dr. Franklin Bailey Smith
Smith was born in Georgia in 1848. He studied medicine under Drs. William A. Lewis and F.S. Abbott before entering the University of Vermont and the medical department of the University of New York. Smith graduated from the University of New York in 1873 and helped to establish the Kent County Medical Society, which still oversees physicians today, in 1912. He began practicing medicine in Coventry in 1880, working with his father-in-law, who was also a physician. His medical practice was located at 2 Park Street in Washington Village. Smith served the community through the influenza epidemic of 1918 and the early part of the 20th century. As a part of his practice, he went to local roadhouses to care for the women who worked there. On one such visit, he counseled a young woman to leave that life before it became her undoing. Many years later, the door to his office opened, and in walked a woman with a child. She asked if he remembered her. Smith did not, so she proceeded to tell him that she was the young woman he had counseled and that she had taken his advice and left the roadhouse. As a result, she had married a good man, had his son, and had a house in Providence. She thanked him for saving her life. Smith died in 1930. (Courtesy of CHS.)

Benjamin Franklin Tefft Jr., Doctor
Tefft was the oldest practicing doctor in Rhode Island when he retired in 1972. He had been practicing for 67 years, and the oldest patient he had ever treated was 104. He was a leading ear, nose, and throat doctor, and he attributed his own longevity to not drinking, not swearing, and only smoking when he was four years old. He was the president of the Nathanael Greene Family Association, formed in 1924. This association currently operates a museum telling about the life of Nathanael Greene, a Revolutionary War general. (Courtesy of WRICHS.)

Angeretta Remington, Midwife
Remington was a widowed mother at 29 with two sons. As her female ancestors had done when Coventry was a new town, she served the local women as a midwife. When the pregnant woman felt the time was near, Remington would go and live with the family until the birth. As all children were born at home and the town did not record those who assisted, the exact number of babies she helped into the world is not known. (Courtesy of Lois Sorenson.)

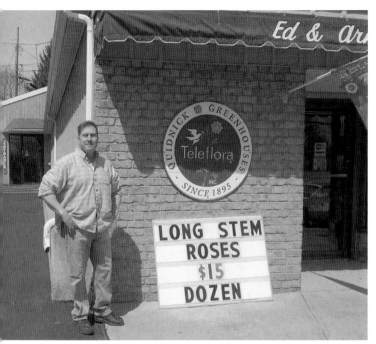

Gregory Iannotti, Florist
The Cushing family built greenhouses and opened Quidnick Florist in 1895. In 1926, the Iannotti family, which already operated a florist shop in Providence, purchased the business. Gregory Iannotti is the fourth generation of the family to run the shop at its current site. He recalls that during the 1960s he and the other Iannotti children used to play Christmas carols on a variety of musical instruments while the shoppers shopped.

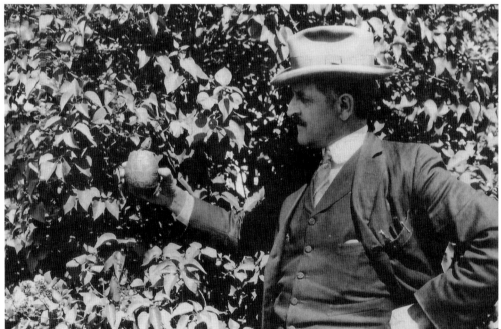

Frank R. Gorton, Funeral Home Director
Gorton was the founder of the Gorton Funeral Home and was also a descendant of Samuel Gorton. Frank learned the trade of the funeral business from Herman Read, Byron Read's son. At one time, the town of Coventry received an ambulance from this funeral home. The Gorton Funeral Home has served the community since 1937, so upon its purchase by Alfred Menard and his wife, Laura Wistow-Menard, in 2001, its name was changed to Gorton-Menard Funeral Home. (Courtesy of PVPHS.)

Byron Read, Businessman
Read owned a furniture and undertaking business in the late 19th century and the early 20th century. He was appointed by the town to provide coffins and perform burial services for Coventry's indigent and Civil War veterans. His funeral home and business were located along Main Street, and the mansion that he built is now used by the Gorton-Menard Funeral Home. Read opened the first emporium in Coventry in 1882. It was 40 feet by 100 feet and had two stories and a basement. The Read family owned a horse named Old Tom, who worked for the family until his death in 1886. At the time of his death, Old Tom had worked over 1,100 funerals. This noble animal was known for his exemplary character and the dignity with which he conducted himself during funerals. (Left, courtesy of PVPHS; below, courtesy of CHS.)

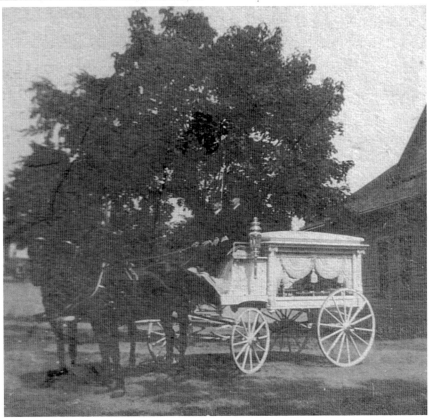

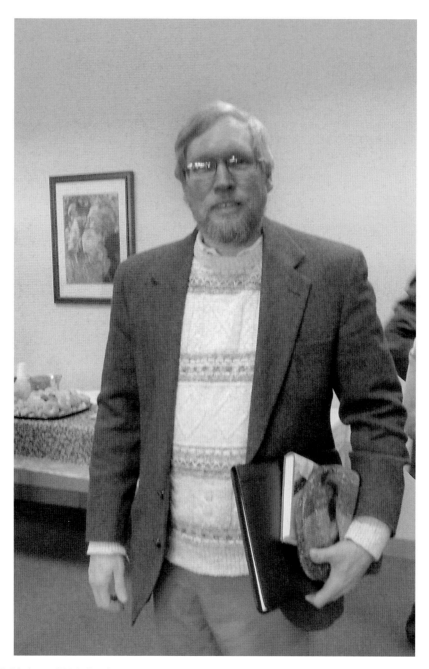

Patrick Malone, Web Designer
Malone is the founder and operator of Marshmallow Fox Web Design. When the company where he worked as a printer left Rhode Island, he went back to school, learned new technologies, and turned his hobby of web design into a career. Choosing his logo became a daunting task as everything he chose was already taken. Malone resides in the country, in a section of Coventry known as Greene. Animal enthusiasts, Malone and his wife began leaving a trail of marshmallows in the yard to entice a fox onto their property. One night, his wife yelled "Marshmallow Fox," and that became his logo. It stuck, and Marshmallow Fox now lures in clients like Nino's on Lake Tiogue and the Coventry Historical Society to create their websites.

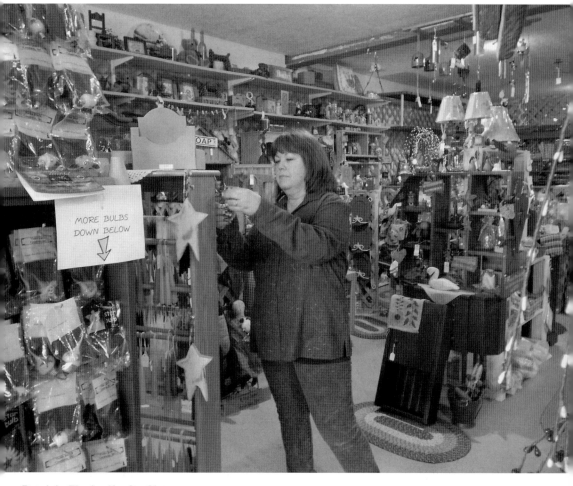

Patricia Florio, Krafty Sisters
Krafty Sisters, run by Florio, Gayle Doyle, Ann McMahon, and Chris Jarbeau, has been in business for 18 years. This group has been friends since childhood and has enjoyed doing crafts together, so it was only natural for them to form a business. The store carries only handcrafted items, many of which are made by Florio and her fellow crafters. Florio takes pride in helping customers get special orders just the way they want them. She says that "during the latest economic downturn many crafters who had made crafts for fun have now turned it into a small business."

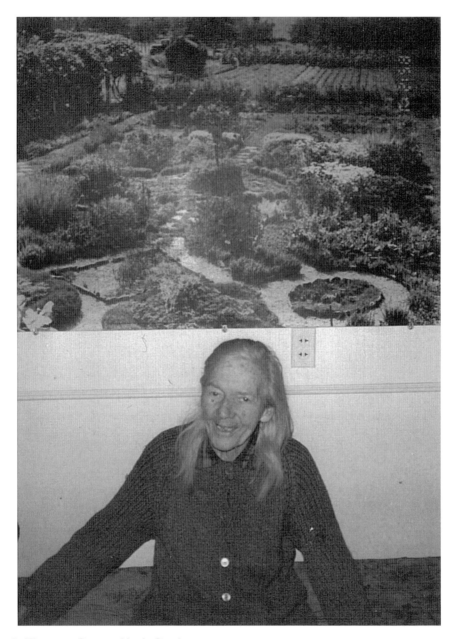

Maggie Thomas, Greene Herb Gardens
In 1942, on a farm in Greene, Maggie Thomas and Mittie Arnold began the Greene Herb Gardens, one of the first wholesale organic gardens in America. Thomas and Arnold would employ local help to work on the farm and would educate the workers about the various herbs. They were not interested in using them for medicinal purposes, but for culinary uses. The Wantaknohow Garden Club would visit the gardens, and Thomas and Arnold would give tours and lectures to the members. They were approached by the Perkins Institute for the Blind to create an herb garden for the visually impaired, and they came up with a design concept using three of the six senses: taste, touch, and smell. The garden was displayed at the Boston Flower Show and was such a success that many garden clubs across America began planting herb gardens for the blind.

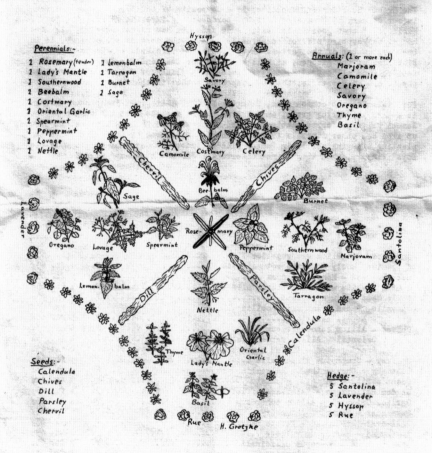

Greene Herb Garden

Perennials:-

1 Rosemary (tender)	1 lemonbalm
1 Lady's Mantle	1 Tarragon
1 Southernwood	1 Burnet
1 Beebalm	1 Sage
1 Cortmary	
1 Oriental Garlic	
1 Spearmint	
1 Peppermint	
1 Lovage	
1 Nettle	

Annuals: (1 or more each)
- Marjoram
- Camomile
- Celery
- Savory
- Oregano
- Thyme
- Basil

Seeds:-
- Calendula
- Chives
- Dill
- Parsley
- Chervil

Hedge:-
- 5 Santolina
- 5 Lavender
- 5 Hyssop
- 5 Rue

GREENE HERB GARDENS

Growers of Fine Seasonings
GREENE, RHODE ISLAND

59

Allen Menton Hopkins

Hopkins was born September 20, 1875, in Coventry and was married to Olive Louise Whitford. As a young man, he began working as a grocery clerk in and around Coventry, assisting people with their purchases and delivering items to their homes. His job as a clerk provided him with a comfortable living to raise his family, which included his son, Elliot Allen Hopkins. After he retired from the grocery business, he went to work as a janitor for the Union Trust Bank until his retirement in 1946 at the age of 71. He died in February 1959. (Courtesy of Lois Sorenson.)

Eugene Fremont Chase, Printer

Chase (standing center) was married to Hattie L. Whitford and owned IF Chase Print Shop in Coventry. The print shop was opened in 1867 by his father, Isaac F. Chase. After Isaac's death, Eugene became the owner, and after his death the ownership passed to his widow. This shop, which was still in business in the mid-20th century, claimed to be the best print-and-stationery shop in the valley and at times was hired to print tax books for the town of Coventry. (Courtesy of Lois Sorenson.)

Elliott Allen Hopkins, Banker
As a young man, Hopkins worked as a bank teller and then as a partner in the Clarke, Kendall & Bradley insurance company. He was elected to the Coventry Town Council in 1936 as a member of the Republican Party. While Hopkins served as president of the town council, it was approached by a concerned citizen to come up with a plan to help veterans find housing. Like a lot of American cities at the end of World War II, the town of Coventry faced a housing shortage. Hopkins was one of five men—two of them returning veterans from World War II—who made up a committee to study the housing problem, specifically focusing on the needs of veterans and their families. Hopkins was also a member of the Rhode Island Draft Board and the rationing board. He died in 1998. (Courtesy of Lois Sorenson.)

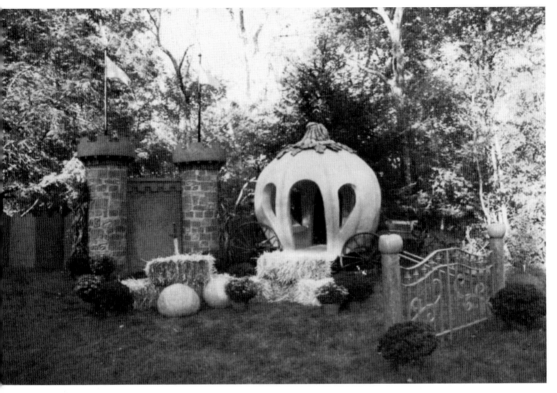

Bruce and Rosemarie Guertin, Magical Affairs

Magical Affairs began when Rosemarie came home and found Bruce, who is a contractor, creating an object that resembled a pumpkin on their lawn. After Bruce painted the pumpkin orange, Rosemarie said, "you know you need a white pumpkin too," and the next thing she knew she came home to a whole carriage. Since then, the Guertins have been creating the whole Cinderella experience for brides and prom goers as the owners of Magical Affairs, which was incorporated in October 2003. The Guertins' daughter dresses up as Cinderella, and each bride or prom attendee receives a handmade photograph album shaped as a pumpkin carriage to keep. In all their many events, the Guertins recall two stories with particular fondness.

Two cousins from Harrisburg, Pennsylvania, discovered Magical Affairs online and began saving their money to hire them for the prom. The mothers of these young women found out about their dream and helped them with the funds. The Guertins recalled loading the pumpkin on the wagon and driving it to Harrisburg for a prom and how everyone looked at the young ladies when they pulled up in the Cinderella coach while the others arrived in limousines.

The white pumpkin carriage is kept in the Guertins' yard and can be seen from the road, and people sometimes stop to have their picture taken with it. On one occasion, a mother and young daughter stopped by so the little girl could pretend to be a princess. When Rosemarie Guertin went out to talk to the mother, she discovered that the little girl had a rare form of cancer and that the mother thought that having her pretend to be a princess might lift her spirits. The little girl had such a wonderful experience that she kept coming back until a few days before she passed. The orange pumpkin is now kept at Roger Williams Park and is part of the Halloween Jack-O'-Lantern Spectacular. To the Guertins, another magical part of this experience is the number of people who have used the carriage and still send them cards. (All, courtesy of Bruce and Rosemarie Guertin.)

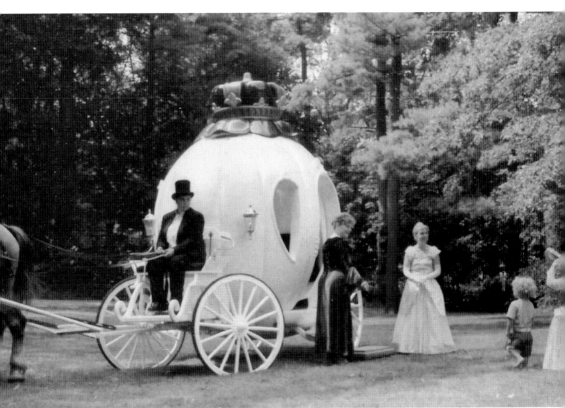

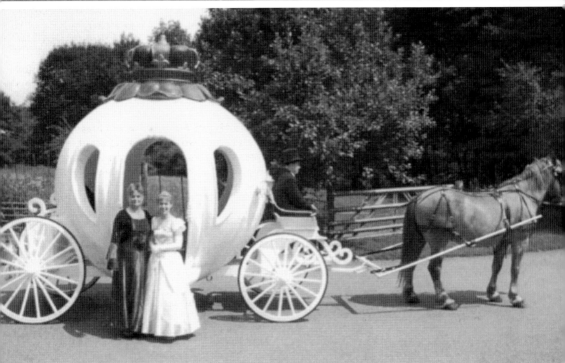

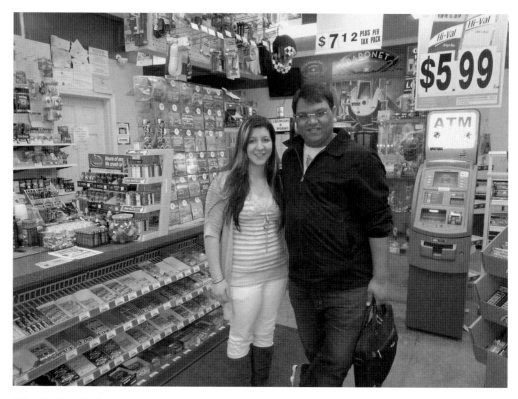

Charlie Patel, Veterans Market

Patel, who has owned the Veterans Market since 2012, was born in India and immigrated to the United States five years ago. After purchasing the store, he made a few changes, but the business has retained its status as a place where neighborhood residents can go pick up a few things and see their neighbors. Patel is continuing to run a business that has been serving the same families for 60 years. In snowstorms, he stays open for people to buy their milk, bread, and eggs. Alyssa Rose, pictured here with Charlie, works with Patel as a clerk.

Hector Poulin, Mill Owner

Poulin moved to Coventry from Woonsocket to rent the mill that had been owned by Searles Capwell. According to his granddaughter Norma Smith, Poulin was hired to drive his truck to tow the boat that would become the famous Showboat restaurant across the lake bottom to the eastern shore of Lake Tiogue. (Courtesy of Norma Smith.)

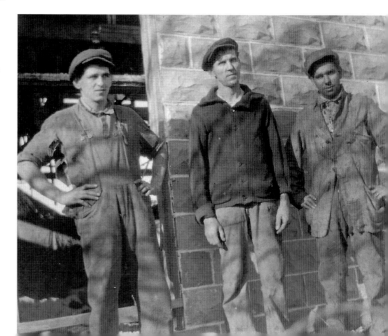

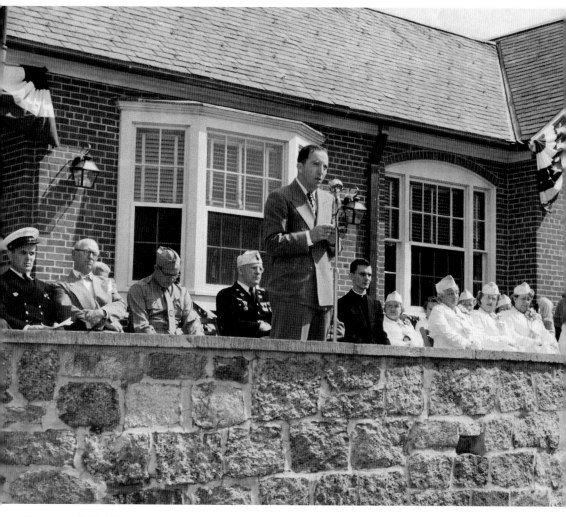

Terrence E. Duffy
Duffy (at microphone) owned a grocery store and served on the town council as the president. He first served as the town clerk beginning in 1954 and was still clerk in 1966. Duffy was also a state senator and served as the acting postmaster in Coventry. It was during his time as town clerk that the memorial to the Coventry men and women who served in World War II was dedicated, and this photograph was taken at that event. Under Duffy's tenure, the town of Coventry expanded, and many new schools and homes were built. In 1969, the town dedicated the community center at the Knotty Oak Village and named it in honor of Duffy. (Courtesy of CHS.)

Grace Smith, Hairdresser and Business Owner
After the death of her husband, Grace Smith, who had small children to support, opened a small beauty shop in her Coventry home. As a widowed woman in an era when women stayed at home, she had a hard time obtaining a loan and acquiring a space to operate her shop. With the assistance of a customer/ friend, Smith was finally able to obtain a loan from Coventry Credit Union and open her shop, which she owned and operated until her death. Her daughter Norma Smith continues the business today under the name Beyond Grace. (Courtesy of Norma Smith.)

CHAPTER SIX

Community Contributors

Besides the businesses, another part of Coventry culture is the men and women who give or have given of their time and money to help their fellow neighbors. The town of Coventry established a poor farm in 1851 to help the less fortunate, and Horatio Nelson Waterman set up a fund to help the poor of the community. Following in his footsteps, Gail Tatangelo has established a community garden to provide food to those in need while giving students the opportunity to meet community-service requirements and providing senior citizens with meaningful tasks such as planting seedlings and watering the gardens. Civil servants in this chapter include William Longridge, J. Francis Remington, Anthony Ottaviano, William Heaton, and Bryan Volpe, as well as senior center volunteers like Marco Marotto and Freda Fisher, who have all contributed to the well-being of the community.

Fundraising and supporting one's neighbor are important to the residents of Coventry, as evidenced by Ray Gandy, who swims to raise money for the Leukemia & Lymphoma Society, and Christopher Moore, who participates in the annual Penguin Plunge to raise money for organizations like the American Cancer Society. Other organizations, such as 4-H and the Wantaknohow Garden Club, create friendships while providing various services to the community. Additionally, Norma Smith and the Friendship Link establish long-lasting friendships worldwide. Others, like George Parker of Parker Woodland, have established permanent preserved areas for the survival of natural habitat and for the people of Coventry to explore and remain connected to nature. Just as Cora Jordan, a local artist, provided the residents of Coventry with paintings of the town's history, Joel Johnson is the current-day driving force behind the committee that is providing Coventry with a lasting tribute in the form of a statue of Nathanael Greene, a famous war hero who resided in Coventry and whose family still maintains his home under the Nathanael Greene Homestead Association.

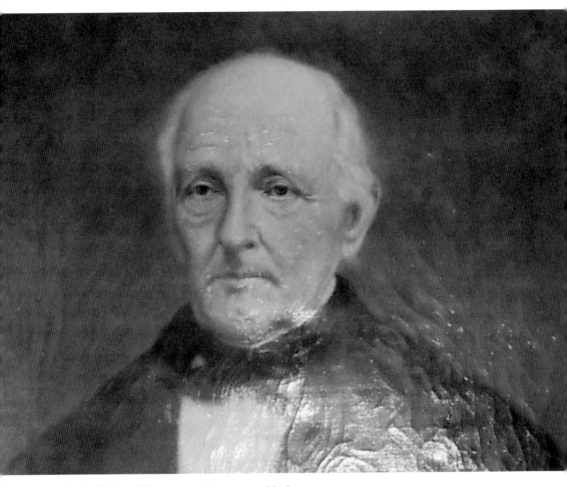

Horatio Nelson Waterman, Farmer and Laborer

Waterman was born February 26, 1806, in a house once visited by Washington, Rochambeau, and Lafayette during the American Revolution. The son of Capt. William Waterman and Hannah Gardner, he was a direct descendant of Roger Williams, the founder of Providence. He worked as a farmer and laborer and lived frugally, saving his money. After his death on June 16, 1891, he left about $50,000 to the town of Coventry in support of the poor. One of the first acts performed with this money was the update of the heating system in the town's poorhouse. The poorhouse, also known as the poor farm, closed by the mid-1940s. This fund was invested and is still used today to help the poor. Waterman is buried in the family cemetery on Bowen Hill, and his portrait hangs in the Coventry Town Hall (where, according to his will, it has to be displayed).

George Burrill Parker, Town Clerk
Parker was born in 1862, when the Civil War was in its second year, and died in 1946. He served as a town clerk and donated 250 acres of land to the town of Coventry in 1941. This property is now known as the George B. Parker Woodland Wildlife Refuge and is part of the Audubon Society. The refuge includes an archaeological dig site that shows the remains of mills and charcoal mounds. The charcoal was used in cold blast furnaces, which were used in mills such as the Hope Furnace Mill, located nearby, and the Greene Forge, owned by Gen. Nathanael Greene's ancestors. The Isaac Bowen House is also on this site and is listed in the National Register of Historic Places. (Right, courtesy of CHS.)

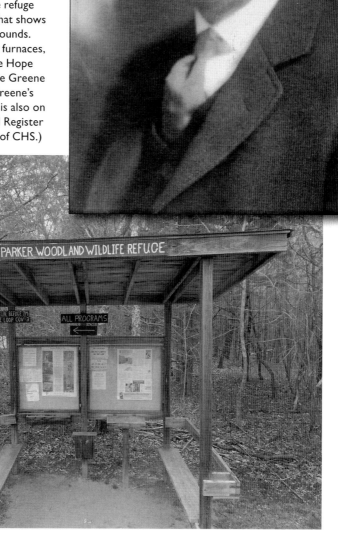

Thomas R. Hoover, Town Manager
Hoover, who has served for 43 years in municipal government, was hired in July 2009 from Royal Oaks, Michigan, to serve as the town manager of Coventry. As the town manager, Hoover is responsible to the town council for the administration of all town affairs on a daily basis. During his administration, Hoover has been guiding the town through difficult economic times.

Bryan Volpe, Chief of Police
Volpe has served as the chief of police in Coventry since January 2011. Before becoming the chief, he served for about 20 years as a Coventry police officer. Over his years of service, he visited the local schools to teach the students about safety. Volpe just recently hired a new officer for the force who had grown up with his children.

William Heaton, Dog Officer

Heaton was an auxiliary police officer until 1968, when he became the one-man Animal Rescue Division. His position required him to take care of all dog ordinances and save animals in distress. Heaton said, "Dealing with the people may be the most important part of the job, but it's the animals that make it all worthwhile." He once saved a dog from drowning in a swimming pool, herded cattle, and caught horses on the run. One of his more embarrassing moments came when he chased a sparrow up and down rows of women's dresses at a dress shop in the Coventry Shoppers Park. Heaton received a humanitarian award from the statewide Volunteers for Animals organization. He served as a US Navy corpsman in the Philippines during World War II and also sang Christmas carols at the Quidnick Baptist Church. In the photograph above, Heaton's family is dressed up for the reenactment of the founding of Coventry held during the 225th-anniversary celebration. (Both, courtesy of Hawkins family.)

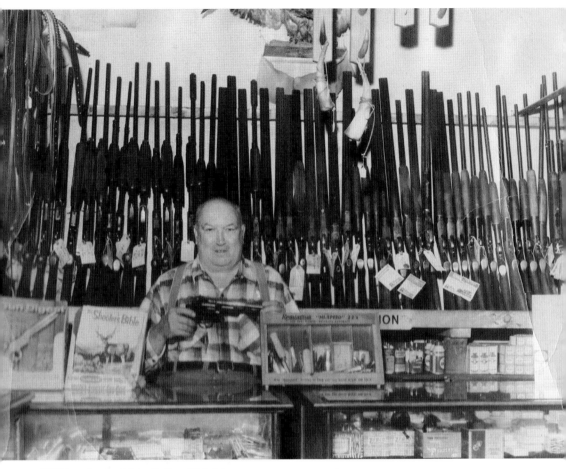

William Longridge, Police Chief (ABOVE AND OPPOSITE PAGE)
Longridge was the chief of police in Coventry from 1924 to 1930, during the age of Prohibition and prior to the transition to a permanent full-time department. He was 25 years old when he was appointed chief of police, and at the time he was the youngest chief to serve in the state of Rhode Island. He was born to Alexander Longridge, who had worked as a mason in the quarry near Hill Farm Road, and Elizabeth Bruce. He was married to Sally Mallie and lived on Whaley Hollow Road on a farm his family called "the Ponderosa." Longridge owned and operated an automobile repair shop and a sporting goods store on Main Street from 1927 until his death in 1967. The shop was listed in the *Pawtuxet Valley Daily Times* as western Rhode Island's largest sporting goods store and was located at 655 Washington Street in the section of Coventry known as Anthony. This is the site where Ice House Flowers stands today. The repair shop and sporting goods store also gave the guys a place to hang out, play cards, and talk politics. Longridge owned a pet monkey named Nippy, which he kept at the garage and his house. He was a veteran of the world wars and was also part of the group that was organized to build a monument to the veterans of World War II. He was a member of the David Papineau American Legion post and marched in parades. He died January 17, 1967, and was buried in the Rathbun Cemetery. He was known for taking young boys fishing and hunting and teaching them about the outdoors, and he was also noted for getting Christmas presents for families in need. Longridge was remembered as "a gruff powerful man who breathed color." Despite his tough, gruff exterior, he gave of himself in many ways. In one instance, when a man broke into his store and robbed the register for money to buy groceries and cigarettes, Longridge sent groceries to the man's family. (Both, courtesy of Robert Maguire.)

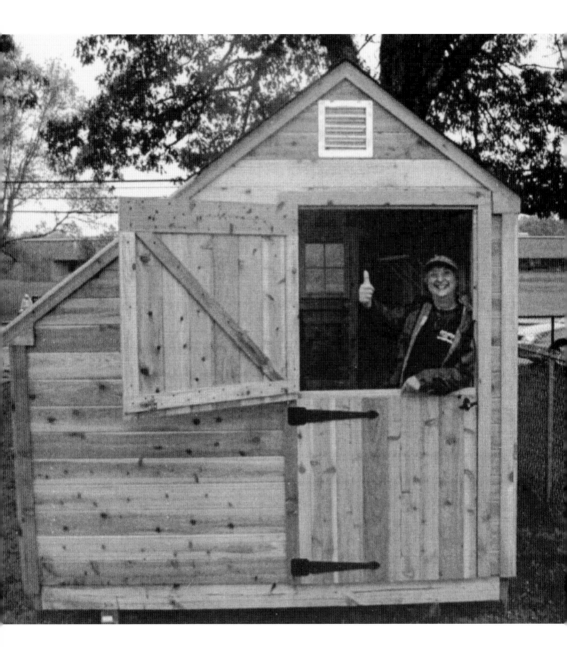

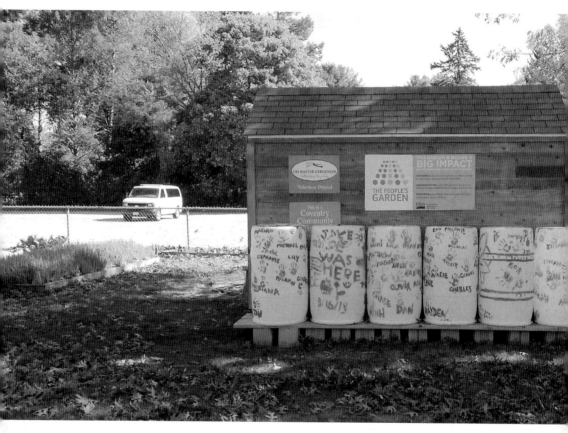

Gail Tatangelo and the Community Garden

Tatangelo, who is a University of Rhode Island master gardener, approached the town of Coventry about starting a garden based on the Victory Gardens of World War II. Tatangelo had noticed that people, especially children, were unaware of healthy eating and the origins of their food. After the town approved the garden location in front of the Coventry Town Hall Annex, she obtained donations of wood and garden supplies. Because of the garden's placement in front of the annex, Coventry residents became aware of it and some began volunteering. Students and seniors help to plant seeds and nurture the plants, making the garden a classroom for the young and old, whose handprints are pictured here. With the help of the Coventry Human Services Department, Tatangelo is able to distribute the food to the needy of the community. In 2012, she accepted a $4,000 grant for this garden from DeLoach Vineyards through a contest hosted by *Organic Gardening* magazine. (Opposite, courtesy of Robert Robillard.)

Marco Marotto
Marotto lives on Breezy Lake in Coventry. There, he has befriended a swan that has a deformity and named her Hilary, and he waits for her annual return to the lake. During his lifetime, he has been a food-safety inspector and a food distributor, so it was only natural for him to volunteer in the kitchen at the Coventry Senior Center two days a week. He also volunteers at the USS Saratoga Museum Foundation in North Kingstown and works as a fundraiser for children with disabilities at the Fogarty Center. He enlisted in the Navy at the end of the Korean War and brought the *Saratoga* into commission in 1956.

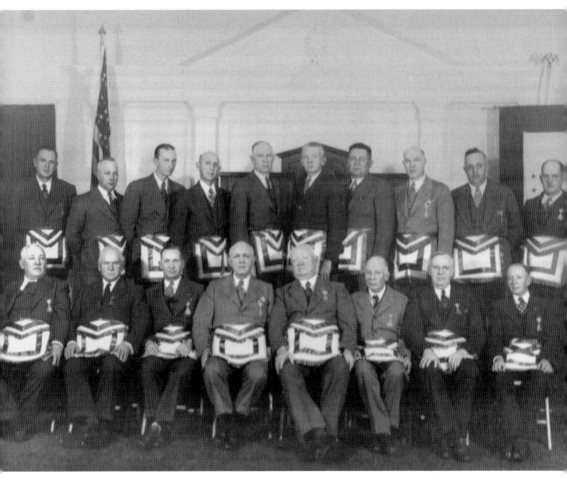

Elmer Capwell, J. Richard Hill, and Walter Perkins
Elmer Capwell (first row, second from right) was a fire chief; J. Richard Hill (second row, second from left) operated a shoelace-tip factory in Coventry and helped to form the Hill Farm Fire Department, and Walter Perkins (second row, fourth from left) owned a fruit store in Coventry. They were all Masons. Coventry is home to two Masonic lodges that have been playing a role in the community since they were formed in the 19th century. The Masons give scholarships for college, host blood drives, and hold family events around the holidays. (Courtesy of CHS.)

HOUSE 1668

CORA A. JORDAN

Cora A. (White) Jordan, Artist

Jordan was a local artist who painted images of Coventry's past. She was born October 17, 1920, in Cranston, Rhode Island, to Edwin W. White and Clara B. Myres, and she died February 13, 1974, while attending a funeral. She was married to Earl Leslie Jordan Jr. who had served in World War II. While her husband was stationed in Germany, she attended art classes. She was a member of the Providence Art Club, the Providence Art Water Club, and the Wickford Art Association, and was president of the Pawtuxet Valley Art Association. She graduated from the Rhode Island School of Design and hosted art shows in the Coventry Shoppers Park for the Coventry Chamber of Commerce. Her art is on display at the Coventry Credit Union and the Paine House. This image of the Paine House is a sample of Jordan's artwork. (Courtesy of WRICHS.)

Fred Curtis, Merchant Marine and Sea Captain

Curtis is a Coventry native who served in the Merchant Marines, during which time he visited 39 countries and served as captain. As a young man, he worked as a gardener for Maggie Thomas and Mittie Arnold at the Greene Herb Garden. While in college, he worked on various boats, including the research vessel the *Endeavor*. Whenever he was on leave, he went back to the Greene Herb Gardens or worked as a schoolteacher in the Plainfield Connecticut School District. Today, Curtis is a gentleman farmer in Coventry and president of the Coventry Historical Society, which is now located in the Old Summit Baptist Church, has a museum in the Summit Free Library, and operates the old one-room Read School House. The Coventry Historical Society held its first meeting April 22, 1971.

Gary P. Cote, Town Council President
Cote is a Democrat who represents District No. 4 and currently serves as the town council president. A lifelong resident of Coventry, Cote is a truck driver by occupation and drives for J. Tartaglia Trucking. He has advocated for improvements in education and the schools of Coventry.

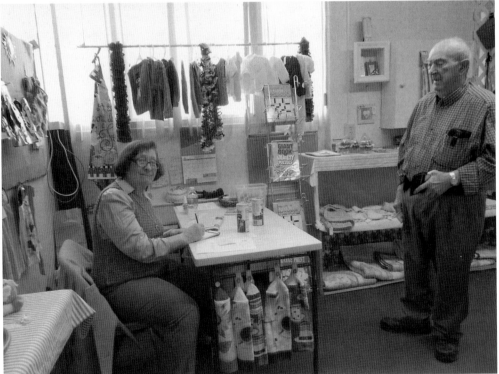

Freda Fisher, Volunteer
Fisher has spent the past 10 years volunteering in the Coventry Senior Center gift shop and kitchen, where she provides a warm and smiling face to all. Everyone at the Coventry Senior Center says, "You have to meet Freda." Fisher introduces visitors to everyone. Fisher came from Boston, where she met her husband, and together they moved to Coventry. She formerly worked for Verizon in the accounting department.

Christopher Moore, Firefighter
Moore is a lieutenant in the Hopkins Hill Fire Department in Coventry. He lives in town with his wife and two children and has been an active member of the department for 10 years. During the day, he works for the state fire marshal, and at night he is a call man for the fire department. He and his fellow firefighters participate in the annual Penguin Plunge to raise money for charity.

Gareld A. Shippee, Police Chief
Shippee was the first police chief of the Coventry Police Department after it became a full-time department in 1948. Shippee served in that position until 1968, and during that time he saw the town's evolution from a farming community to a bedroom community of Providence. Shippee was a veteran of World War II and is seen here in the Coming Home Parade of 1946. (Courtesy of Rachael Pierce.)

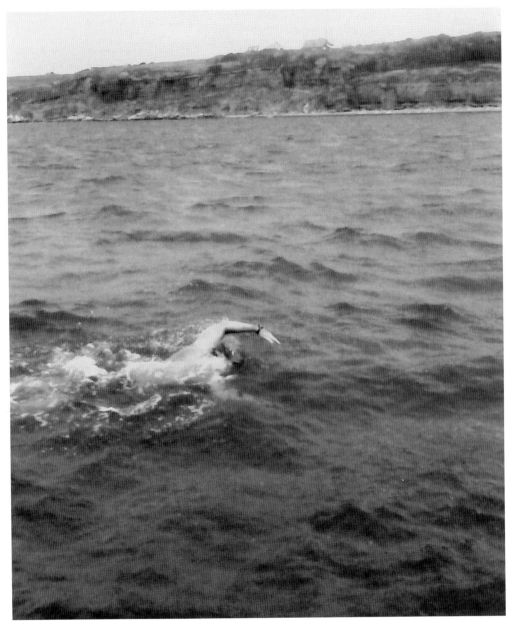

Ray Gandy, Swimmer

Gandy began swimming at the age of nine. When he was in college at Clarion University in Pennsylvania, he was a repeat NCAA Division II All-American swimmer. After the birth of his daughter in 1990, his life changed. His wife was diagnosed with chronic myelogenous leukemia. Gandy stopped swimming until 2000, by which time his wife had virtually recovered. Today, Gandy is an open-water marathon swimmer. In 2009, he became the first and only Rhode Islander to successfully cross the English Channel. In 2010, he was the first person to swim around Conanicut Island, which he circled twice in one swim. He swam the 57th-longest swim in history in July 2011 when he swam for 27 hours and 42 minutes in Narragansett Bay. One of Gandy's goals is to raise money for the Leukemia & Lymphoma Society of Rhode Island. (Courtesy of Ray Gandy.)

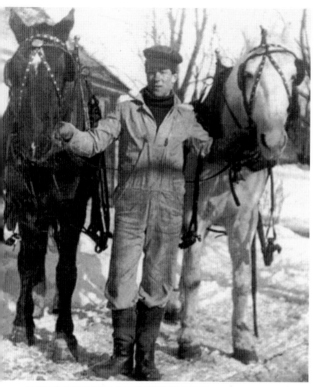

John Francis Remington, Town Constable

Remington was born in 1892 and grew up on a farm in Coventry. He was the grandson of Philip Johnson Jr., a Boston Post Cane recipient. His family, pictured below on the couch, includes, from left to right, Russell Franklin Tourgee (grandson) holding the infant Jo-Ann Tourgee (great-granddaughter), Helen Mae (Remington) Tourgee (daughter), John Francis Remington, and Angeretta (Whitford) Remington (mother). The image at left shows Remington working the horses on the farm. Having grown up on the family farm working with animals, it was only natural that he was appointed to be the pound keeper. In addition, Remington was a town constable in the early 20th century, and according to his cousin William Marcotte of Crystal Cleansers, he used to direct traffic at the intersection of Main Street and South Main Street. He died in 1968. (Both, courtesy of Lois Sorenson.)

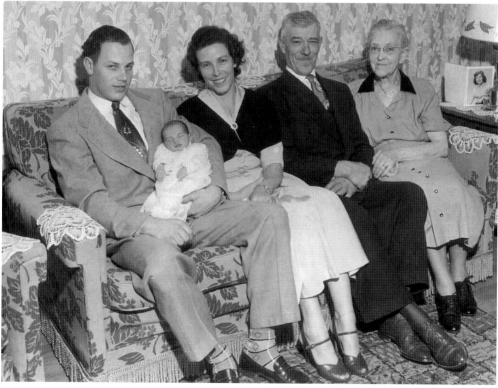

Joel Johnson, Nathanael Greene Statue Advocate

Johnson, a lifelong Coventry resident, had an inspiration for a statue of Nathanael Greene when he first visited the Nathanael Greene Homestead in Coventry as a young boy. Greene had owned and operated a forge in Coventry before becoming a general in the Continental army and second in command to Gen. George Washington. The homestead still stands today, now known as Spell Hall, and is a museum dedicated to telling the story of Greene and his family during their time in Coventry. Generations of schoolchildren have visited this museum. With the dedication of a monument to Greene in Greensboro, South Carolina, the idea for the statue in Coventry resurfaced in 2008. In August 2012, Johnson and others formed a nonprofit organization known as the Nathanael Greene Monument Foundation. Johnson wants to put the statue in Coventry because there is currently no statue of Greene in town despite his vital role in the area's economy and his pivotal role in the American Revolution. The foundation began investigating locations for the statue and is now leaning toward a piece of land near a bridge that was just dedicated to Greene. The statue is based on the existing statue in Greensboro. Edward Walker and James Barnhill are the artist and the sculptor for this project. When completed, the statue will be 22 feet tall. Johnson hopes to have the public schools participate in fundraising. The organization's board of directors consists of all Coventry residents.

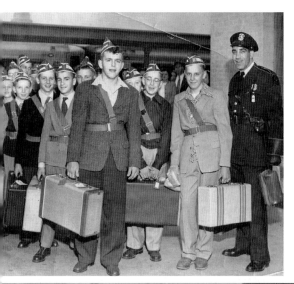

Anthony C. Ottaviano, Police Officer
Ottaviano was a member of the US Navy in World War II. After serving, he became a Coventry police officer on the first permanent police force under Gareld Shippee. Ottaviano served as the director of the Coventry Junior Police Corps in 1953. In the photograph at left, Officer Ottaviano took a group of Junior Police Corps members to Washington, DC. Serving as the Coventry school safety patrol director, Ottaviano had the privilege of congratulating Stanley S. Stasiowski Jr., a seventh grader at St. Mary's Parochial School, for pushing several children to safety when a car careened toward a line of students crossing the street. (Both, courtesy of Coventry Police Department.)

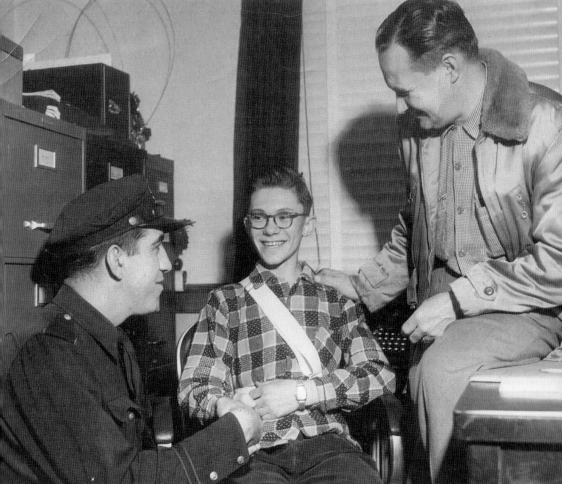

Charles M. Vacca Jr., Journalist and Lawyer
Vacca grew up in Centredale, Rhode Island, and majored in history and economics at the University of Wisconsin. He worked as a journalist for the *Coventry Townsmen* and is currently a lawyer. He is a past president of the Pawtuxet Valley Preservation and Historical Society, has served as the chairperson for the Coventry Republican Party, and is a member of the Pawtuxet Valley Preservation and Historical Society Cemetery Group. Vacca is a strong supporter of history and civic pride and credits the *Golden Book of America* for his interest in history.

Cheryl Ring, Leader of Wag'N Tails

4-H is a national organization whose mission is to offer youth the opportunity to address the four Hs—Head, Heart, Health, and Hands. Cheryl Ring (right) has been involved in 4-H for six years and is the current leader of Wag'N Tails, a Coventry chapter whose focus is dogs. In addition to dog training, members learn leadership and public-speaking skills and participate in community-service projects and fundraisers for local animal shelters as well as for at-risk families. Shown below are Kelly Bryant (left) and Jessilyn Ring with their artwork that was recently entered in the Photo Fine Arts Fair (where Bryant received the People's Choice award and Ring received Best in Show for the photograph of her dog). Both girls feel 4-H has provided them a variety of experiences and agree that dog training has made them very competitive.

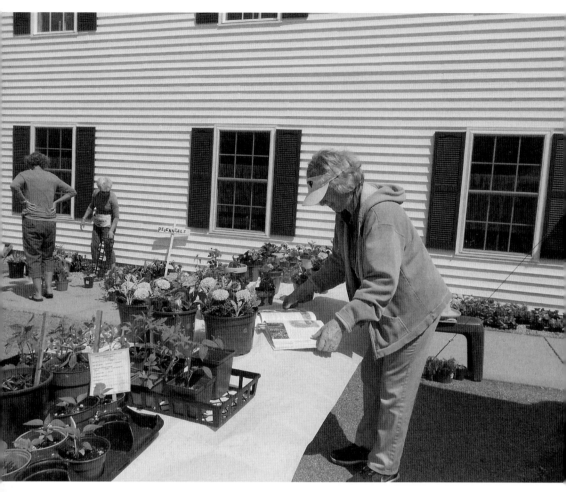

Sandy Farnum, President of the Wantaknohow Garden Club (ABOVE AND OPPOSITE PAGE)
In the group image opposite are, from left to right, Debbie Fisher, Candy Haas, Sandy Farnum, Sharon St. Martin, Sandi Fisher, Etta Izzi, and (in front) Mary Sunderlin, officers and members of the Wantaknohow Garden Club, which was started in 1938 by a group of women in western Coventry. In 1983, the club joined the Rhode Island Federation of Garden Clubs. The organization holds an annual plant sale to benefit the Wantaknohow Garden Club Scholarship (given to students who are studying environmental science) and other local civic projects. The club's current civic project, known as Adopt-A-Spot, involves planting and maintaining the flowers around the Greene Library. Gail Slezak from the Greene Library is an associate member. President Sandy Farnum believes the club is a way of sharing gardens with the community and says, "Gardeners are perennial."

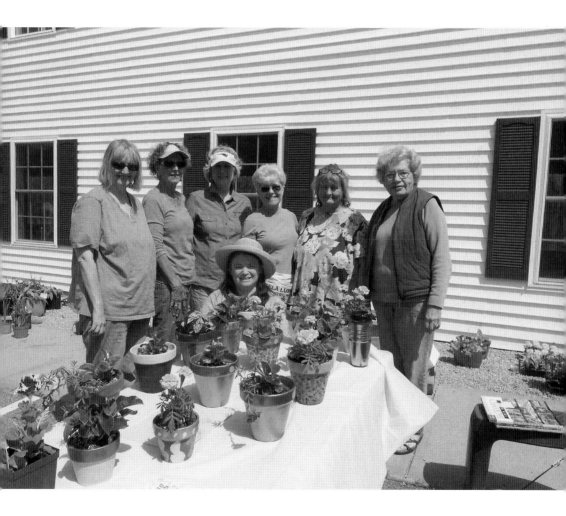

Norma Smith, Coventry Friendship Link

The Coventry Friendship Link was formed in 1975 when the lord mayor of Coventry, England, visited Coventry, Rhode Island, to establish a cultural relationship between the two cities. The first group of visitors arrived in 1975 from England to stay for two weeks. The image above shows Norma Smith, a past secretary of the organization, in England as part of the exchange. The sister cities are now Coventry, England; Vannes, France; and Meschede, Germany. In 1992, visitors from Germany came to Coventry, and much to the surprise of one of the women in their group, a friend originally from Germany who was now living in Arizona and whom she had lost contact with in the early stages of World War II had made arrangements to be at the home of the host here in Coventry. An offshoot from Coventry's Boy Scout Troop 11 became Troop 76 as an exchange-scout link. (Both, courtesy of Norma Smith.)

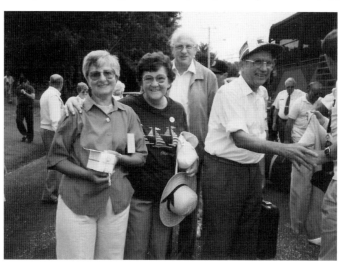

CHAPTER SEVEN

Authors and Educators

Coventry has been home to many authors since the 19th century, when Annie Kilton began composing poetry and stories about life in the village of Anthony. In this chapter, readers will meet Robert Grandchamp, who has written numerous Civil War books and articles focusing on Rhode Islanders who served in the war, and Linda Crotta Brennan, who has authored children's books and numerous stories for children's magazines.

Librarians and educators have been inspiring and shaping the minds of Coventry's youth for generations, and in this chapter readers will be introduced to just a few, such as Carrie Ina Jordan Shippee, Mary Harvey, Nichole Hitchner, Peter Stetson, Diane Simmons, and Gail Slezak.

Education in colonial Coventry was sparse and usually took place at home. The town did not have a public schoolhouse until 1765, and it was not until 1800 that the town began to use taxes to support education. Coventry was divided into 18 school districts, and each district had to provide the wood, school supplies, and teachers for the summer and winter sessions. Most schools were one-room structures with separate entrances for boys and girls. Teachers boarded with local families during their terms. As the town developed and new immigrants of different faiths arrived, parochial schools were established. Education was also supported by the establishment of free libraries in Anthony and Summit in the 19th century. There remain two libraries today—one in Greene and the main branch attached to the town hall—and children's programs, computer classes, and employment resources are available there. In 1926, Coventry ran evening classes. In the 1940s, the town decided to consolidate the individual school districts into five new districts. The town constructed new schools of brick and concrete to replace the one- and two-room clapboard structures.

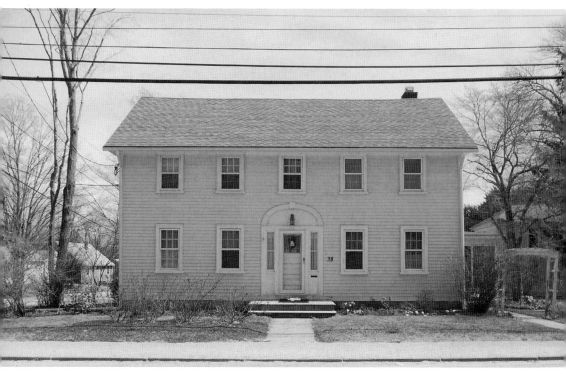

Anne Kilton, Poet
Kilton was a Coventry poet who wrote a poem in 1910 titled, "The Village of Eighty Years Ago." She was a descendant of the Brayton family, one of the founding families of Coventry. This poem describes life in the village of Anthony in 1830, and the Pawtuxet Valley Preservation and Historical Society used it to create a walking tour of Anthony. Anne's grandfather was a Revolutionary War soldier and a member of the party that burned the HMS *Gaspee*, a British Ship that got stuck on a sandbar in Narragansett Bay off the coast of Warwick. This image is of her house at 38 South Main Street in the village of Washington.

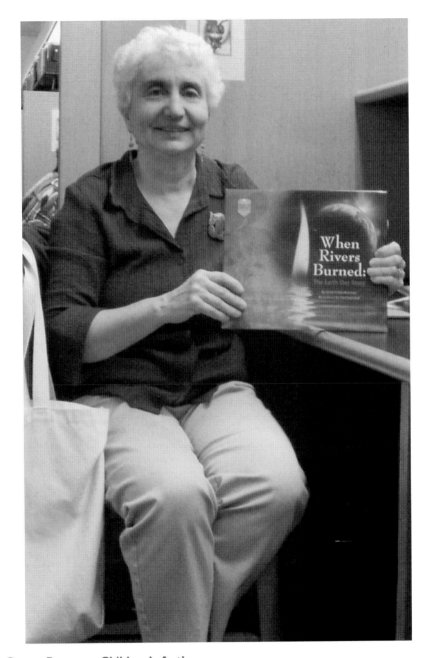

Linda Crotta Brennan, Children's Author
Brennan has authored over a dozen children's books and numerous stories for children's magazines such as *Highlights for Children*, *Ranger Rick*, and *Cricket*. Her latest book is *Where Rivers Burned: The Earth Story*. She also authored *Women of the Ocean State*, which is part of the *American Notable Women* series. Her book *Flannel Kisses* was designated one of Kathleen Odean's Great Books for Babies and Toddlers, and *Marshmallow Kisses* was nominated as one of the Best Children's Books of the Year by Bank Street College. This book also won the Oppenheim Toy Portfolio Gold Seal Award. Brennan worked at the Coventry Public Library and served on the Rhode Island Teen Book Award committee. She is a member of the Society of Children's Book Writers and Illustrators and the Author's Guild.

Peter Stetson, Science Teacher (OPPOSITE PAGE)
Stetson, an environmental earth science teacher at Coventry High School, has been teaching for 36 years. He is also a cochair for the Envirothon Club. Students who attend his classes learn about aquaculture and also work on projects such as raising rainbow trout. Stetson's easy-going personality and his hands-on techniques help him interact with the students. He started a garden at the high school, and when they put the addition on the school he worked with the architect to design the greenhouse. Stetson has received numerous awards and grants for his work teaching students about the environment. He is also involved with the Wantaknohow Garden Club.

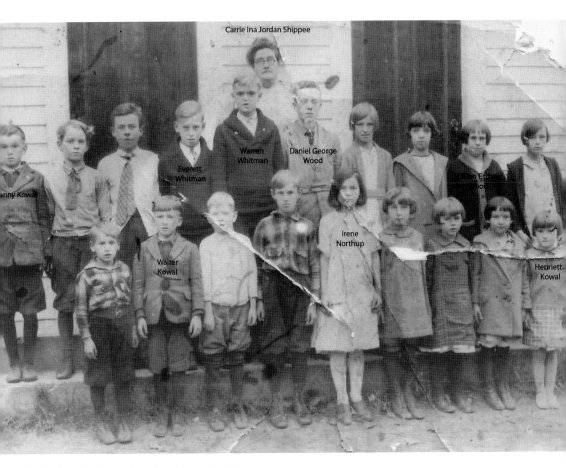

Carrie Ina Jordan Shippee, Schoolteacher
Shippee worked as a schoolteacher at Spring Lake School in Coventry during the early 20th century. She had come to Providence in 1910 from Connecticut, where she was born, to attend the Rhode Island Normal School. After graduation, she returned to Connecticut and began teaching. She returned to Coventry and was married in 1913, and started a teaching career that would impact the lives of many students. In 1940, at the age of 60, she was still teaching. A former student recalled seeing her working late in the night on lessons. Here, Shippee stands in the center background with her students. (Courtesy of Rachael Pierce.)

Nichole Hitchner

Hitchner has worked for the Coventry School System for the last 17 years. She received both an undergraduate and master's degree in education from Rhode Island College. Her introduction to teaching started in 1989 when she volunteered in a program that helped students with special needs. Her love of teaching is immediately felt when she begins talking and explaining how she interacts with students who have learning issues. She travels around the school districts, working with teachers on assessing the progress that the students are making and strategizing on how to reach students who are having difficulty excelling. As with Carrie Ina Jordan Shippee, it is not uncommon for parents to drive past a school and see Hitchner working after hours.

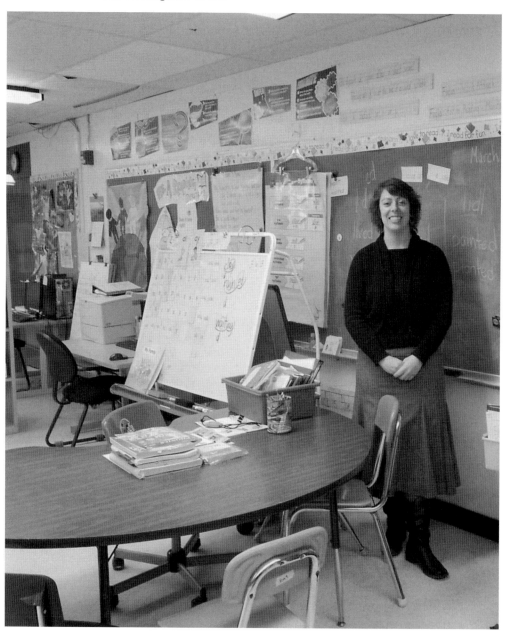

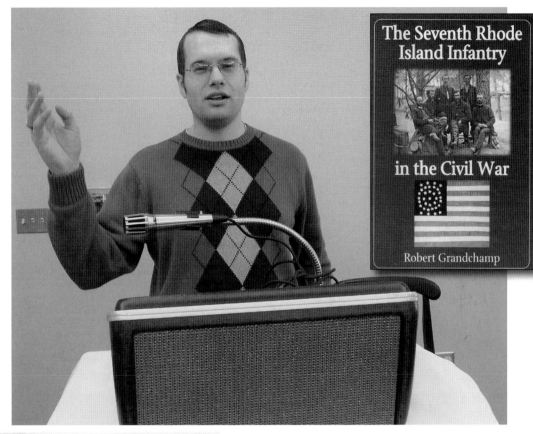

Robert Grandchamp, Author

Grandchamp is the author of numerous Civil War books and articles focusing on Rhode Islanders who served in the war. His book *The Seventh Rhode Island Infantry in the Civil War* includes William Rathbun, whose story is also included in this book. Grandchamp is a graduate of Coventry High School and Rhode Island College. He is currently employed by the Department of Homeland Security, working in Vermont.

Julie Lima Boyle, High School Teacher

Boyle is a graduate of Coventry High School. She received her bachelor of arts and master of arts degrees from Rhode Island College and her teacher's certificate from Providence College. She has been a teacher in Coventry schools for 13 years and is the department chair for the English department at Coventry High School. In 2011, she was named the Coventry Teacher of the Year and the Rhode Island Teacher of the Year. (Courtesy of Coventry Patch.)

97

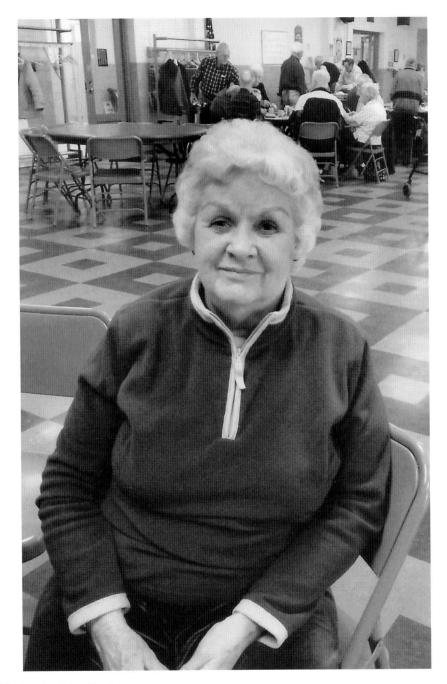

Gail Lake, Aspiring Author
Lake began writing her life story in 1978 as a means of coping with the death of her mother when she was eight years old and the death of her husband at the young age of 42. She started by writing about the house she had lived in. She began her story as memoirs but, having since taken writing courses, is in the process of changing her memoirs into books. In addition to being an author, Lake has been running the Sociable Group at the Coventry Senior Center for 13 years. Members have to be single, and Lake makes all the arrangements for their outings to plays, museums, and more.

Mary M. Harvey, Teacher and Principal
Harvey was a teacher at the Washington Village School who later became principal. Child Incorporated, which operates a federally funded Head Start daycare program, is housed in the former Washington Village School today. In this 1925 image with the children of the school, Harvey is the woman on the left in the black hat. (Courtesy of CHS.)

Tara D'Aleno, Elementary School Teacher
Editor Lauren Costa announced in the online Coventry Patch newspaper that Tara D'Aleno had been selected as Teacher of the Year for Coventry for the 2012–2013 school year. D'Aleno, who is a teacher at Tiogue Elementary School, stated that she was inspired by her father, who is also a teacher. (Courtesy of Coventry Patch.)

Graduates of Combine

Coventry Elementary Schools 1926 Graduation

The Coventry Elementary Schools graduation of 1926 was held in June, with 119 graduates from 11 grammar schools. One ceremony was held at the Odd Fellows Hall in Anthony, while a separate graduation took place for the new Quidnick School in its assembly hall. Rev. Henry Parson gave the invocation and presented the diplomas at the Odd Fellows Hall. Parsons was the pastor of the Quidnick Baptist Church and was also the clerk for the Coventry School Committee. The address was given by Col. Merton

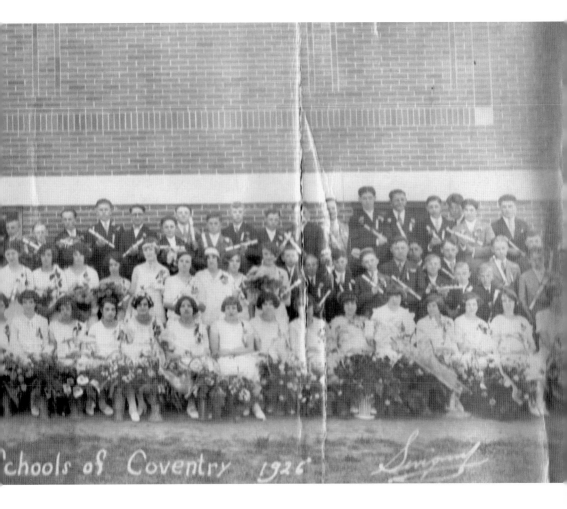

Cheesman. Officers of the class were president Harold Young of Quidnick, vice president Lloyd A. Moon of Washington, secretary Mary C. Murningham of Harris, and treasurer Elizabeth MacClintock of Quidnick. The executive committee consisted of Philip H. Matteson of Maple Valley, Mary E. Kowal of Spring Lake, Harry O. Capwell of Summit, Harry L. Warner (future owner of Warner Rustic) of Read, and Susan A. Tew of Rice City. (Courtesy of Coventry Public School System.)

Guy Lefebvre, Director
Lefebvre has been the director of Coventry Parks & Recreation since October 1978 and has worked in the town for over 34 years. He began working as a referee for youth sporting events at the age of 14. He went on to college and, after graduation, went to work for the town of North Smithfield. Under his directorship, he helped to create the bike path system utilizing the old trestle trail. He served on the committee to celebrate the 250th anniversary of Coventry in 1991 and is active in preserving and promoting the history of Coventry. The Coventry Teen Center offers programs for children, teens, and young adults as part of the Parks & Recreation Department.

Diane Simmons, Youth Services Librarian
Simmons is the Youth Services Librarian at the Coventry Public Library located at 1672 Flat River Road. She provides story time for children of various ages and assists in the preparation of special events held during school vacations. She works outside the library at various day care centers, encouraging children to read and visit the library. Simmons, who usually wears the same perfume when working at the library or visiting schools and day cares, recalls, "One day I had cut through a preschool to get into the toddler room. When the preschoolers came in from recess, the teacher later told me, one little girl said, 'I can smell Mrs. Simmons!' " The Coventry Public Library is a member of the Ocean State Libraries system, and Simmons has worked there for 20 years.

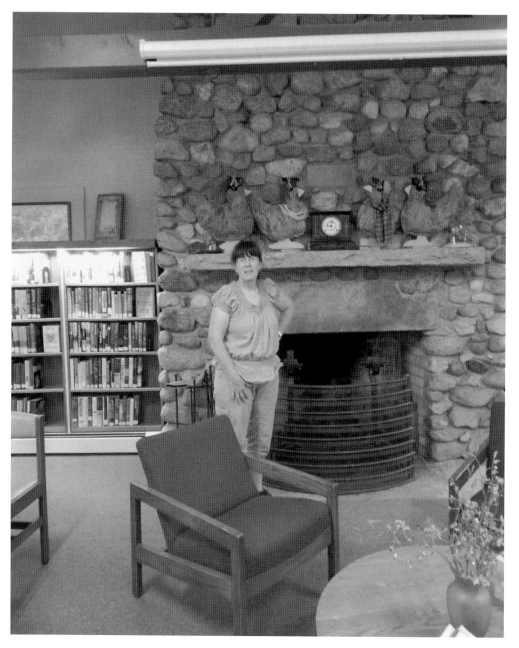

Gail Slezak, Librarian

Slezak began working 30 years ago as the cleaning lady at the Greene Public Library and worked her way up to a position at the desk. She then spent 10 years working at the Scituate Public Library and has spent the last five years as the head of circulation at the Greene Public Library. She has lived in Greene for 32 years and has noticed how the Greene Public Library is just a living room where one can see all their neighbors. She is now coming to know the children of the adults that she knew as children. As a child, she wanted to be a farmer. She learned how to farm from Maggie Thomas of the Greene Herb Garden, and she and her husband rented Nicholas Farm when they first got married. Slezak rides her bicycle to work when weather permits and has become known as the "bicycling librarian."

CHAPTER EIGHT

News of the Day

In the early days, messages were sent by rider or by stagecoach along the Old North Road and the Country Road. The telegraph poles would have also brought news to families in the area. With the coming of the trains, newspapers that were being printed in Providence could be shipped to rural areas of Coventry and distributed to the small local stores.

Before 1876, the newspapers that served the Coventry area were based in Providence and were the *Providence Evening Bulletin* and the *Daily Journal*, which had been started by Henry B. Anthony. This newspaper would have brought information about the election of Henry B. Anthony as governor of Rhode Island, the wounding of William Rathbun during the Civil War, and local job announcements. These announcements played an important role in attracting immigrants to Coventry.

In 1876 the *Pawtuxet Valley Gleaner* was established, and as time went on, other newspapers were started, including the *Pawtuxet Valley Daily Times*, the *Coventry Townsman*, the *Kent County Daily Times*, and the *Coventry Courier*. All of these newspapers served the Coventry area at various times, and the *Kent County Daily Times* and the *Coventry Courier* are still in existence today. The Stevens family started a weekly circular known as the *Coventry Reminder* in 1954 that is still published today. This circular reminds residents of upcoming events at the local libraries, the Wantaknohow Garden Club, and the Coventry and Western Rhode Island Civic Historical Societies. It also publishes advertisements for local businesses.

With the coming of the Internet age and the decline in published newspapers, the need for an online news source was apparent. Thus, Lauren Costa brought the Coventry Patch to the community. This online newspaper provides residents with the opportunity to blog and to obtain news around the clock, which helped many residents during the blizzard of 2013.

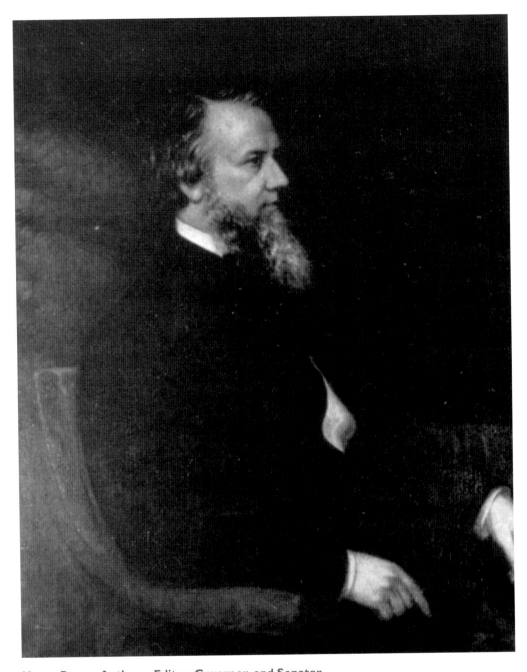

Henry Bowen Anthony, Editor, Governor, and Senator
Anthony, editor of the *Providence Journal*, was born in the Anthony section of Coventry on April 1, 1815, into a prominent family that was involved in the Society of Friends (also known as the Quakers). He attended the local public school, which at that time was located where Ice House Flowers stands today. Anthony graduated from Brown University and was married to Sarah Aborn Rhodes until her death. He was a member of the Whig Party and the Law and Order Party, and served as governor of Rhode Island from 1849 to 1851. He also served as a US senator from 1859 until 1884. His lieutenant governor, Thomas Whipple, was also from Coventry. (Courtesy of PVPHS.)

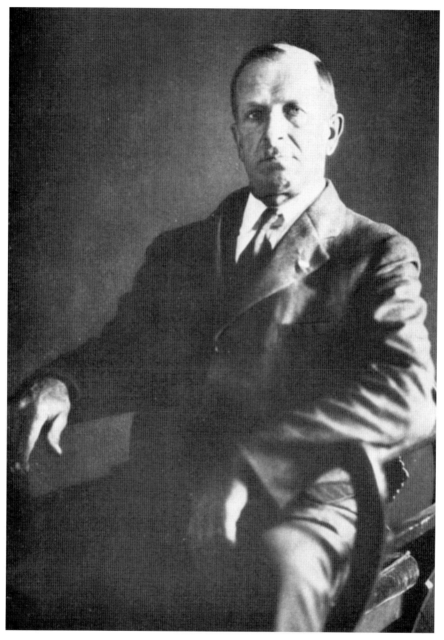

Irving Pearce Hudson, Editor, Auditor, Representative, and Senator
Hudson was born August 5, 1873, to J. Ellery Hudson and Eliza J. Pearce. He worked at the *Pawtuxet Valley Daily Times* before he became the editor in 1906. He became the auditor for the town of Coventry and was a member of the Coventry Republican Town Committee. From 1910 until 1914, he served as a representative, and in 1915 he was elected senator, serving at the state house. After his death in 1949, his widow, Thirza, continued to operate the *Pawtuxet Valley Daily Times* until her own death in 1961. Their four daughters, Dorothy I. Havens, Lucy M.H. Potter, Marion T. Goddard, and Thirza H. Chettle, served as the board of directors. This newspaper is now known as the *Kent County Daily Times*. (Courtesy of PVPHS.)

Lauren Costa, Editor (OPPOSITE PAGE)

Hurricane Irene of 2011 not only had an impact on the state of Rhode Island but on the Coventry Patch as well. Editor Lauren Costa reported that having a good rapport with people in the community allowed her the opportunity to set up in the command center and report directly to people's cell phones the power-outage restoration schedule, free-water locations, availability of showers, and other necessities as the damage from this powerful hurricane left many Coventry residents without power for days. After power had been restored and life started to return to normal, Costa remembers receiving emails and phone calls saying that the Patch had helped them find the news they needed; thus the Coventry Patch became a means for people to connect with the outside world, increasing its readership and popularity. Today, Costa invites members of the community to blog on this site, submit articles of interest, and report daily happenings. An annual happening in Coventry is the Tree Lighting Ceremony held every December in front of the Coventry Parks and Recreation Center to herald the start of the holiday season. Pictured opposite is Costa previewing a photograph she had just taken for use in the Patch.

Lauren Costa is a graduate of Coventry High School and has remained a Coventry resident utilizing her education in communication from the University of Rhode Island and her love of journalism to serve the people of her hometown. She began her journalistic career in middle school working on the school newspaper. After graduating from high school, she attended the University of Rhode Island and interned at the *Warwick Beacon*, learning the trade of journalism. She believes in the printed word but understands that the future of the newspaper is going to be online. While a student at URI, Costa heard of the Patch, an online news source for local communities started by AOL. In 2010, Costa decided to launch the online newspaper Coventry Patch. Her first journalism teacher was Julia Lima Boyle, 2011 Teacher of the Year.

The Coventry REMINDER
your weekly shopping guide ★

627 Washington St. Coventry, R. I.

Est. 1954

Mail Advertising Mimeographing

Wedding Invitations

Business and Social Stationery

Howard and Luella Stevens

Howard Stevens, Founder and Publisher
The *Reminder*, a circular published by Stevens Publishing Inc., was founded in 1954 by Stevens in his home. He worked as the publisher until his retirement in 1991, and his children Peter Stevens and Amey Stevens Tilley now operate the *Reminder* at 1049 Main Street. This circular offers the Coventry community a place to advertise their employment services, yard sales, businesses, real estate, and restaurant coupons. The population relies on this publication to find out the goings-on in the community. (Above, courtesy of Coventry Police Department.)

CHAPTER NINE

Boston Post Cane Recipients and Honorees

The Coventry residents mentioned in this chapter have contributed to the fabric of the community not by giving money or time, but by providing their neighbors something to celebrate. Unlike today, extreme longevity was not as common in the early days of the community, so members found ways to honor those who lived a long life. The Boston Post Cane award was established in 1907 by the *Boston Post* to recognize the oldest resident of each town in New England. Both the cane and the plaque are on display in the Coventry Town Hall. The individuals represented in this chapter have been honored because they provide a link into Coventry's past. One such person, Mary Thompson, was born on Decoration Day 1914 and has witnessed the evolution of Coventry from an industrial center to a bedroom community, from a place of streetcars to one of automobiles. German-born Herman Rusauck, who represents the American dream, was the last recipient of the Boston Post Cane in Coventry in 1994. He died December 31, 1997, and is buried in Coventry.

Also mentioned in this chapter are two individuals who did not set out to receive awards. Linnea LaPointe was going on vacation and ended up having the honor of being an ambassador from the littlest state welcoming the biggest state into the union, and Jeffrey Hakansack was simply living by his motto—Preserve, Protect, and Improve—by cleaning up Lake Tiogue for future generations when he was recognized as the Hero of Conservation by *Field and Stream* magazine in 2009.

Philip R. Johnson Jr., Boston Post Cane Recipient (ABOVE AND OPPOSITE PAGE)
Johnson was born in 1822 and died in 1914. He was married to Tryphena Hoxsie Greene in 1849, and they had five children. His second wife was Phebe Wood Pine, with whom he had one daughter. He had many grandchildren and great-grandchildren. Margaret Estelle Whitford, on his lap on the opposite page, was one of his great-granddaughters. Johnson was a farmer who lived in the Paine House at one time. He was awarded the Boston Post Cane in Coventry. The Boston Post Cane was established in 1907 by the *Boston Post* to recognize the oldest resident of each town in New England. (Both, courtesy of Lois Sorenson.)

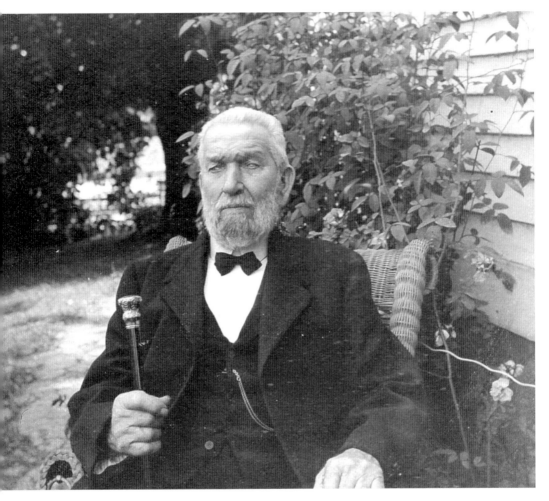

Samuel Augustus Edmunds, Boston Post Cane Recipient
Upon the death of the previous Boston Post Cane recipient, Philip R. Johnson, the cane was passed to Samuel Augustus Edmunds, who was born on March 4, 1821, and died February 28, 1916, at the age of 94 years, 11 months, and 24 days. Edmunds worked in the coal industry in Providence and made a considerable fortune, which he used to build a beautiful home in East Greenwich. During the economic downturn of 1893, he lost some of his fortune and decided to leave the coal business and open a market in East Greenwich. After the death of his wife, he moved to Main Street in Washington Village to live with his daughter Mary Edmunds. Herman Rusauck, who was the last recipient of the Boston Post Cane in Coventry in 1994, was born July 31, 1896, and died December 31, 1997. He is representative of the American dream, having been born in Germany, immigrated to the United States, bought a piece of land, and started a farm here in Coventry. He had two children, Ernest G. Rusauck and Karen A. DiPadua. (Above, courtesy of Richard Siembab.)

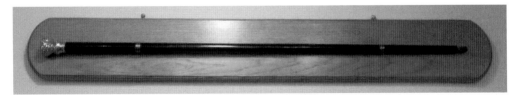

Pardon S. Peckham, Leading Industrialist

Peckham was born in 1822 and died in 1921. He was a leading industrialist in the town of Coventry, owning and operating a mill in Spring Lake and one in Coventry Centre. He began the mill at Spring Lake in 1871 and retired in 1895. He was also responsible for building the Christ Episcopalian Church in Coventry Centre. His wife, Hannah Gorton, was a direct descendant of Samuel Gorton. (Courtesy of PVPHS.)

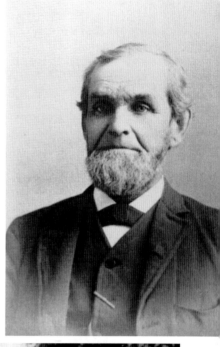

Charlotte Spencer

Spencer (seated second from right) was awarded the Boston Post Cane by Germain Saute, Coventry Town Council president, in August 1968 when she was 94 years old. She had resided in Coventry for 60 years and was the mother of 11 children. She had 22 grandchildren, 57 great-grandchildren, and 4 great-great-grandchildren when she received the Boston Post Cane. (Courtesy of Marie McShane.)

Linnea LaPointe, Goodwill Ambassador (ABOVE AND OPPOSITE PAGE)
LaPointe was a Coventry resident in 1958 when, at the age of 13, she was going on vacation and ended up having the honor of being an ambassador from the littlest state welcoming the biggest state into the union. LaPointe recalled that she had saved enough money to visit her aunt and uncle in Alaska when the press found out about her trip and the politicians decided to make a big deal out of it. Rhode Island governor Dennis Roberts sent a letter and three bags of goods representing the products of Rhode Island with her to Alaska governor Mike Stepovich, welcoming Alaska to statehood. Flying all by herself, LaPointe was met by the acting governor, as Governor Stepovich was in the District of Columbia signing the law making Alaska a state. LaPointe also recalled the beauty of the state and the hospitality of the people. After she returned, she was invited to talk about her trip to the Catherine Littlefield Greene Chapter of the Daughters of the American Revolution. (All, courtesy of Linnea LaPointe.)

Mary Colvin Thompson
At the age of 99, Thompson represents a living link to Coventry's past. She was born at home on Decoration Day in 1914 and recalls going to the Maple Valley one-room schoolhouse and passing only a couple of houses along the way. Thompson worked as a weaver at the Stillwater Worsted Mill. She is still actively attending the Coventry Senior Center a couple of times a week.

Jeffrey Hakanson, Hero of Conservation
Hakanson was named the Hero of Conservation for the month of March 2009 by *Field and Stream* magazine. He received this distinguished honor for his work on restoring the spillway on Lake Tiogue and was presented a proclamation by the Coventry Town Council. He is a past president of the Tiogue Lake Association and is a letter carrier. He lives by the motto, Preserve, Protect, and Improve.

CHAPTER TEN

Faith of the Immigrants

The individuals mentioned in this chapter helped to foster the spiritual growth of the town of Coventry. When the population of western Warwick separated to form a new town, the majority were of the Baptist faith, followed by the Quaker faith, whereas today there are not only Baptists but also Methodists, Catholics, and Jehovah's Witnesses. Families such as the Greenes, Anthonys, and Pecks were strong Quakers, while the Gortons, Bennetts, and others were Baptists. Religion was an important part of the lives of the early settlers because of the precariousness of life and death at that time. Mortality was high because of disease and accidents related to the establishment of the town. As the town grew and developed with the Industrial Revolution, the demand for labor meant more immigration. These new waves of immigrants brought new religions with them. These new churches not only provided the new immigrants a place to worship but also a place to learn to interact with different cultures and a safety net in the new, uncertain land. Early on, the immigrants shared church space with the existing religions, but as the communities and the congregations grew, the need for separate churches and religious leaders representative of their congregations' cultures arose.

A few notable religious leaders were Fr. John Marianski from Poland, who served as the leader for the new Polish church; Rev. Timothy Greene, the first pastor of Maple Root Baptist Church; Perez Peck, who served as an elder in the Quaker Church; and today Fr. Paul Grennon, who preaches at SS John & Paul Catholic Church, and Richard Seelenbrandt and Robert Johnson, who serve as elders for the Jehovah Witnesses. Continuing on in the tradition of Samuel Gorton, who settled Warwick on the basis of religious freedom, residents of Coventry are still enjoying that freedom today.

Timothy Greene, Pastor
On May 17, 1744, Baptists living in Coventry asked permission of the Baptist church in Warwick to form their own church. Maple Root Baptist Church was organized October 14, 1762, when 26 members gathered together and chose Timothy Greene to be their pastor. Greene was ordained as minster of the new church on September 1, 1763. Under his pastorate, the church flourished, and he performed three marriages during this time. Greene served the congregation until he moved to the Midwest in the 1770s. Greene, who came from West Greenwich, was married to Silence Burlingame by Elder James Colvin, and they became the parents of eight children. Many of the founding families of Coventry—including the Rice, Colvin, Greene, Harrington, Whaley, and Gorton families—attended this church, as their descendants do today.

John Marianski, Priest

Rev. Matthew Harkins, the head of the Catholic Diocese of Providence, was approached by the growing Polish community about establishing their own place of worship. Like many other immigrant groups in the region, the Polish people were attracted to Coventry because of the availability of work. Construction began in 1906, and when the new house of worship was completed and dedicated, the Polish community chose the name Our Lady of Czenstochowa Church in honor of a famous church in Poland. The story of one of the church's earliest priests, John Marianski, goes that his name was really John M. Nowicki and that he was on the Russian Czar's blacklist and could not return to his native Poland. So, when the opportunity arose to come to Rhode Island and serve as a priest, he came to Our Lady of Czenstochowa. The current priest is Fr. Stephen Amaral, and the church is still a vital part of the Coventry Polish community, sponsoring festivals throughout the year.

Rev. Daniel L. Bennett and Nathan O. Bennett (ABOVE AND OPPOSITE PAGE)
Daniel L. Bennett, above right and opposite page, was born in Apponaug to Daniel E. and Mary (Bennett) Bennett on March 22, 1847. His brother, Nathan O. Bennett, above left, was born on July 4, 1844. Their father fell under the spell of the gold fever in 1849 and left for California when Daniel was only two years old. The story goes that Bennett's father died along the way, leaving his mother a widow with six young children. Bennett received a basic education but never completed school. As he grew up, he worked for various manufacturing companies until he heard the call from God in 1877. In the course of his ministry, he served 50 years in Coventry and attended to countless baptisms, 483 marriages, and 952 funerals. Besides being a church elder, he owned and operated a farm with his wife, Sarah, and their children Charles and Carrie, and with his second wife Sarah. Rev. Bennett died February 11, 1928, in Coventry. Florence Capwell sang three hymns at his funeral that were chosen by Rev. Bennett himself. Nathan Bennett became a general contractor, constructing buildings throughout the state until the age of 85.

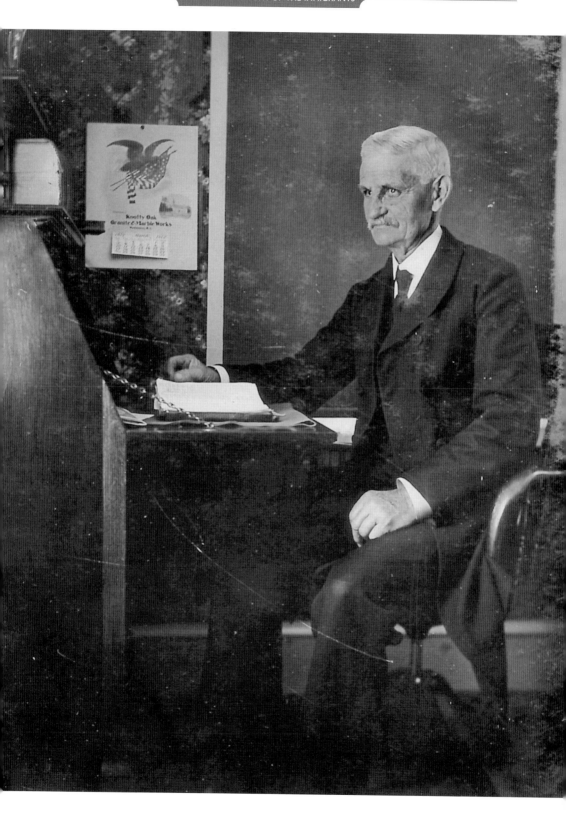

Fr. Paul Grennon, Priest

Grennon, who was raised in Pawtucket and educated in New York, has served at SS. John & Paul parish since 2003. This parish was established in 1955 and was consecrated in September 1957. The church is located along Tiogue Ave and South Main Street and has one of the largest congregations in the Providence Diocese. It has about 5,000 families. (Above, courtesy of Marie McShane; right, courtesy of Father Grennon.)

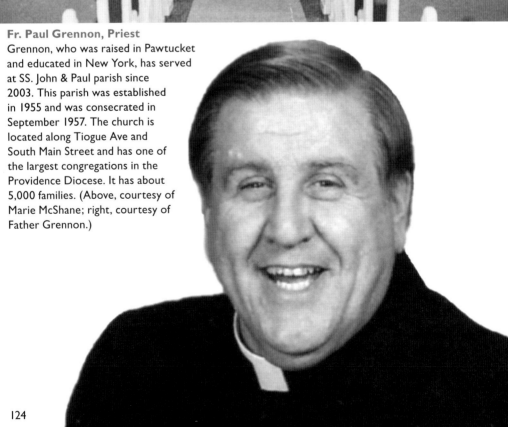

Perez Peck, Quaker

Peck served as an elder and was a member of the Quaker faith. Peck, who was an abolitionist, also owned a machine shop that produced machines for new cotton mills. As an abolitionist, he was a supporter of the practice of only using cotton that had been picked by free men. After Peck's death, Searles Capwell acquired the property and machine shop and converted it into his blinds-and-sash works that was later bought by Hector Poulin. The remains of this shop are still there today. Peck was an active member at the Quaker meetinghouse until he died in 1876. As with many religions, the congregation decreased, and the building was sold. In 1926, this building was converted to the Polish National Alliance Club.

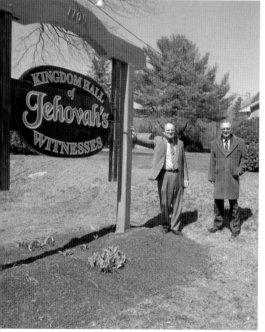

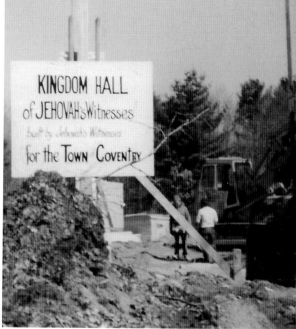

Richard Seelenbrandt, Elder

Seelenbrandt (left) and Robert Johnson (right) are both elders in the Coventry Jehovah's Witness hall. Seelenbrandt is a carpenter by trade, and when there is a disaster, he and other volunteers travel to the area to assist in the rebuilding. Seelenbrandt has been to Costa Rica, Florida, Mississippi, and recently, New Jersey, cleaning up and rebuilding after earthquakes or hurricanes. Each Elder shepherds or looks after the well-being of about 20 families. Seelenbrandt believes in home visitations as a way of staying connected with the families and the community.

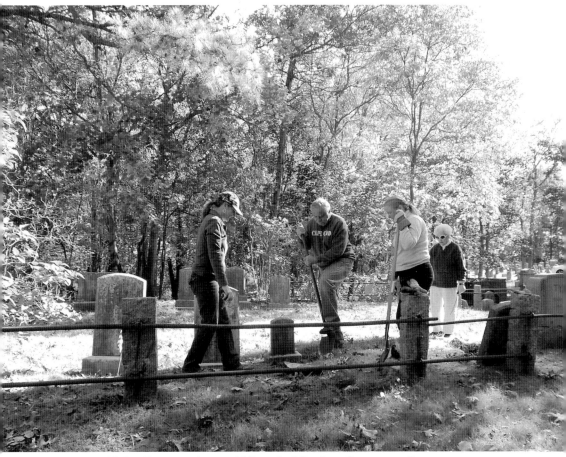

Pawtuxet Valley Preservation and Historical Society Cemetery Group

From left to right, Maureen Buffi, Bob Chorney, Julie Nathanson, and Joan Hamlin are members of the Pawtuxet Valley Preservation and Historical Society Cemetery Group. This group began as the Friends of the Coventry Cemeteries in 2005 to help preserve historical cemeteries in the town of Coventry. They mey at various locations in Coventry until the group, which is made up of volunteers, grew and needed to find a bigger place to meet. The Pawtuxet Valley Preservation and Historical Society offered them space on the condition that the group would take on the task of preserving the cemeteries of West Warwick as well. With this merger, the group adopted its current name. They meet once a month to discuss which cemeteries need to be cleaned up, photographed, or, in the case of lost cemeteries, found. Cemetery cleanups are then planned for weekends. Volunteers bring their own tools and provide the labor. The town provides dumpsters. This group resurrects, repairs, and documents gravestones during its cleanup projects. In this image, they are preparing to level the base so they can resurrect a fallen gravestone. Often, property owners or neighbors participate in the cleanups as well. The group has located cemeteries that were reported as lost, as well as a few gravestones that had not been seen for over a century.

INDEX

Amaral, Bob, 36
Andrews, George Washington, 32
Anthony, Henry Bowen, 106
Beattie, John William "Jack," 41
Beattie, William James "Jim," 44
Bennett, Rev. Daniel L., 122
Bennett, Nathan O., 122
Black Rock, 11
Bleir, Alphee "Kid Blair," 18
Borges, Deana, 24
Boyle, Julie Lima, 97
Brennan, Linda Crotta, 93
Brown, Oliver, 29
Bryant, Kelly, 87
Bucklin, Joseph, 15
Bucklin, Susanna, 15
Buffi, Maureen, 126
Capwell, Elmer, 77
Capwell, Searles, 40
Carbuncle Pond, 12
Card, Randall, 26
Carlson, Harry, 22
Cavanaugh, Danny P., 25
Chase, Eugene Fremont, 60
Chorney, Bob, 126
Costa, Lauren, 109
Cote, Gary P., 80
Coventry Elementary class of
 1926, 100–101
Curtis, Fred, 79
D'Aleno, Tara, 99
Delehantey, Mary Agnes, 34
DeMarco, James, 22
Dubuc, Arthur , 35
Duffy, Terrence E., 65
Edmunds, Samuel, 114
Essex, Edward, 30
Farnum, Sandy, 88
Fisher, Freda, 80
Florio, Patricia, 57
Foster, Horace N., 45
Gandy, Ray, 82
Gorton, Frank R., 54
Gorton, Samuel, 10
Grandchamp, Robert, 97
Greene, Rev. Timothy, 120

Grennon, Fr. Paul, 124
Guertin, Bruce, 62
Guertin, Rosemarie, 62
Hakanson, Jeffrey, 118
Hamlin, Joan, 126
Harvey, Mary M., 99
Heaton, William, 71
Hill, J. Richard, 77
Hill, James T., 30
Hitchner, Nichole, 96
Holland, Gail, 51
Hoover, Thomas R., 70
Hopkins, Allen Menton, 60
Hopkins, Elliott Allen, 61
Hudson, Everett E. Sr., 43
Hudson, Everett E. Jr., 37
Hudson, Irving Pearce, 107
Hudson, Richard, 35
Iannotti, Gregory, 54
Jacob, Brenda, 15
Johnson, Joel, 84
Johnson, Philip R. Jr., 113
Johnson, Robert, 125
Jordan, Cora A. (White), 78
Karapatakis, Stamatis, 24
Kilton, Anne, 92
Kilton, John Jenckes Jr., 16
Lake, Gail, 98
LaPointe, Linnea, 116
Lavigne, Omer, 20
Lefebvre, Guy, 102
Longridge, William, 72
Maguire, Joseph, 46
Malone, Patrick, 56
Marcotte, Leslie, 48
Marcotte, William, 48
Marianski, Fr. John, 121
Marotto, Marco, 76
Moore, Christopher, 81
Nathanson, Julie, 126
O'Connor, Corey, 38
Ottaviano, Anthony C., 85
Paine House, 14
Papineau, David, 31
Parker, George Burrill, 69
Pastille, Albert, 22

Patel, Charlie, 64
Patterson, Charles, 30
Peck, Perez, 125
Peckham, Pardon S., 115
Perkins, Walter, 77
Phillips, Robert, 36
Phillips, Tillie, 36
Potter, George W., 28
Poulin, Hector, 64
Proffitt, George, 49
Rathbun, William, 29
Read, Byron, 55
Remington, Angeretta, 53
Remington, John Francis, 83
Ring, Cheryl, 87
Ring, Jessilyn, 87
Rusauck, Herman, 114
Seelenbrandt, Richard, 125
Shippee, Carrie Ina Jordan, 95
Shippee, Gareld, 81
Simmons, Diane, 103
Skaling, Kim, 50
Slezak, Gail, 104
Smith, Dr. Franklin Bailey, 52
Smith, Grace, 66
Smith, Norma, 90
Spencer, Charlotte , 115
Sprague, George B., 30
St. Jean, Philip, 37
Stetson, Peter, 95
Stevens, Howard, 110
Tatangelo, Gail, 75
Tefft, Dr. Benjamin Franklin Jr., 53
Thomas, Maggie, 58
Thompson, Mary Colvin, 118
Vacca, Charles M. Jr., 86
Veterans of Foreign Wars, 30
Viens, Henry, 23
Volpe, Bryan, 70
Warner, George, 20
Waterman, Horatio Nelson, 68
Whitford, Charles William, 42
Wood, Daniel George, 33
Zarakostas, Nico, 23
Zarakostas, Louie, 23

AN IMPRINT OF ARCADIA PUBLISHING

Find more books like this at
www.legendarylocals.com

Discover more local and regional history books at
www.arcadiapublishing.com

Consistent with our mission to preserve history on a local
level, this book was printed in South Carolina on American-
made paper and manufactured entirely in the United States.
Products carrying the accredited Forest Stewardship Council
(FSC) label are printed on 100 percent FSC-certified paper.

MADE IN THE
USA